PRAISE FOR
MAKE YOUR OWN PIXEL ART

"This book will give you an introduction to the tricks of the trade of making tech-
nologically simpl[e] but artistically potent drawings, including ways to animate
them. . . . A good investment."

—GREG LADEN

"This is a fun book that opens up many possibilities. Highly recommended to those
who want to learn pixel art."

—TEOH YI CHIE, Parkablogs

"The graphics support the instructions in the book, and help to make things very
easy to understand. All the techniques described, step by step, could easily hold
the attention of a younger reader, and would also be interesting for adults who
are just getting into pixel animation."

—JOHN BREEDEN, *Game Industry News*

"Filled with personality and charming illustrations, *Make Your Own Pixel Art* is sure
to become the go-to resource for mastering pixel art."

—MOTHERHOOD MOMENT

Make Your Own
Pixel Art

Jennifer Dawe

Matthew Humphries

Create Graphics for Games, Animations, and More!

no starch
press

San Francisco

Printed in Korea
Fourth Printing

26 25 24 23 22 4 5 6 7 8 9

ISBN-10: 1-59327-886-1
ISBN-13: 978-1-59327-886-1

Publisher: William Pollock
Production Editors: Serena Yang and Janelle Ludowise
Cover and Interior Design: Mimi Heft
Developmental Editor: Jan Cash
Technical Reviewer: Susan Lin
Copyeditor: Paula L. Fleming
Proofreader: Emelie Burnette
Compositors: Serena Yang and Kim Scott, Bumpy Design

For information on distribution, translations, or bulk sales, please contact No Starch Press, Inc. directly:

No Starch Press, Inc.
245 8th Street, San Francisco, CA 94103
phone: 415.863.9900; info@nostarch.com
www.nostarch.com

Library of Congress Cataloging-in-Publication Data:
Names: Dawe, Jennifer, author. | Humphries, Matthew, 1978- author.
Title: Make your own pixel art : create graphics for games, animations, and
 more! / Jennifer Dawe and Matthew Humphries.
Description: San Francisco : No Starch Press, 2018.
Identifiers: LCCN 2018032665 (print) | LCCN 2018038672 (ebook) | ISBN
 9781593278878 (epub) | ISBN 159327887X (epub) | ISBN 9781593278861
 (paperback) | ISBN 1593278861 (print) | ISBN 9781593278878 (ebook)
Subjects: LCSH: Computer graphics. | Computer games--Design. | Computer
 animation. | Computer art--Technique. | BISAC: COMPUTERS / Digital Media /
 General. | DESIGN / Graphic Arts / General.
Classification: LCC T385 (ebook) | LCC T385 .D424 2018 (print) | DDC
 006.6--dc23
LC record available at https://lccn.loc.gov/2018032665

Dedicated to Christopher, Amanda, Say,
and of course, to you, the aspiring pixel artist!

About the Authors

Jennifer Dawe is a self-taught animator and character designer who has worked as a professional pixel artist for the past 15 years. You can usually find her on Twitter @gmshivers posting doodles and answering questions about drawing and digital art.

Matthew Humphries is Senior Editor at PCMag.com and a professional game designer. Over the past 15 years, he has worked for Disney, 20th Century Fox, and Games Workshop, among others. You can find him on Twitter @mthwgeek.

Contents

Preface

1
Pixel Art Tool Guide

2
Shapes and Shading

3
Colors and Palettes

4
From Concept to Complete

5
Get in the Game

6
Animating Pixels

7
Special Effects for Animation

8
Where to Go from Here

appendix
Aseprite Shortcut Cheat Sheet

Acknowledgments

There are a handful of people who made this book possible: they are Serena Yang, Janelle Ludowise, and of course, Bill Pollock. There's also everyone else at No Starch Press who worked behind the scenes to make this publication happen. It took exactly two emails for No Starch to see the potential in this book and to come on board, and for that, we are very grateful.

Also, we must thank David Capello, the author of Aseprite. His continued efforts to improve the software and give both new and professional artists an affordable option for creating pixel art are very much appreciated. There are a variety of pixel art tools out there, but none come close to Aseprite in our opinion.

Then there's the community of aspiring artists, both young and old, who are very eager to become pixel artists but have found little in the way of resources to help them. It's these people who inspired us to write the first draft of this book and then to carry on improving it. Thank you for your questions, your encouragement, and hopefully a place on your bookshelf.

I think we also owe each other a pat on the back. Through writer's block and artist fatigue, we supported each other and struggled through the lows and celebrated the highs together.

Preface

I lived in the Arctic for the first few years of my life, where there wasn't much to do. Then in 1986, my dad (thankfully) invested in a computer.

It was love at first sight. As I watched my dad make elaborate drawings of cars and monsters using Microsoft Paint, I realized art wasn't just something to be consumed. You could learn to create it and, with practice, get really good at it.

When my family moved from the Arctic to another remote area, the computer came with us. I spent many nights taking turns playing games and drawing in a coloring book program with my brother.

I've had my head buried in one art program or another ever since.

This book is a culmination of everything I've learned about pixel art in the 30 years since my dad brought home that computer. I've included everything I wish I'd known starting out so you can get a head start on your journey into the exciting world of pixel art.

Jennifer
Twitter: @gmshivers

What Is Pixel Art?

Pixels are tiny dots that form a grid to make up every electronic display we use. By coloring in pixels on this grid, we can create text, images, and animation. In *pixel art*, everything is drawn using pixels. Think of making pixel art as drawing with graph paper: you fill in little squares one by one to create your image.

Drawing one pixel at a time may sound tedious, but that's where software tools come in. They can speed up the process while still giving you complete control over every single pixel.

Pixel art dominated video games in the early days of consoles. Today, even though 3D games are the norm, pixel art games maintain their popularity.

Who Is This Book For?

This book is aimed at beginners and focuses on teaching pixel art creation, but for experienced artists, it will serve as a useful reference. Also, while we create our pixel art using Aseprite throughout the book, the concepts in the book apply to all pixel art, so you should be able to follow along with the software of your choice.

Do I Need a Drawing Tablet?

Any old computer mouse works perfectly fine for most pixel art. In general, you don't need a drawing tablet for pixel art, but it can be useful after you've mastered the basics or when you draw larger scenes. To follow the examples in this book, you'll only need a mouse.

Recommended Software

While this book uses the pixel art program Aseprite, you'll be able to do the exercises with any pixel art software. Lots of well-known and expensive art programs are available, but they are overkill for pixel art and can be overwhelming for beginners. Our suggestion is to stay away from those programs—at least initially.

Here are a few programs we recommend for beginners based on ease of use and low cost:

Aseprite (*http://www.aseprite.org/*)

This very affordable program is made especially for pixel artists. It's a great animation tool for $15, and a trial version is available for free. This is the program we'll use in the book since it's compatible with Windows, macOS, and Linux.

Pro Motion (*http://www.cosmigo.com/*)

This feature-rich program is made with slightly advanced users in mind, but it's still accessible for beginners. A free version is available, though it's made primarily for Windows computers.

GraphicsGale (*https://graphicsgale.com/us/*)

This free program has features similar to those of Aseprite, but it does have some limitations and only works on Windows computers.

Don't feel tied to these recommendations—find what works for you!

Let's Get Started!

Now that you know a little bit about me, pixel art, and the programs you'll use, it's time to sit down at a computer and learn how to use Aseprite!

1

Pixel Art Tool Guide

This book will teach you how to make pixel art using the standard tools included in all pixel art software. Everything you learn in this chapter and the rest of the book will be relevant and easy to follow whether you use Aseprite, GraphicsGale, Pro Motion, or some other software.

In this chapter, you'll get a quick introduction to one of the most popular and feature-rich pixel art applications—Aseprite. We're focusing on Aseprite because it's available to use across the widest range of operating systems (Windows, Mac, and Linux), offers a wide range of features, and is actively being maintained and improved.

Installing Aseprite

You can download Aseprite from its official website at *http://www.aseprite.org/*. Click either **Buy Now** or **Trial Version**. The trial version includes all the features of the software, except saving. If you're unsure whether you want to buy Aseprite, experiment with the trial version first. A license costs $15, and the investment is worthwhile since Aseprite is the only tool you'll need for all your pixel art creations.

Working with a Canvas

When Aseprite first loads, you'll see a screen consisting of three windows contained in a tab called Home. These windows list files you've recently opened, folders you've recently accessed, and the latest Aseprite news.

If you open Aseprite immediately after downloading it, you'll see the message "Aseprite is up to date" in the upper-right corner of the tab. This message changes to inform you when a new version of Aseprite is available to download.

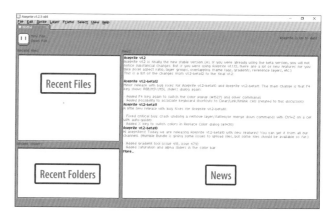

Creating a Canvas

Now that you have Aseprite up and running, let's start by making a canvas! Think of the canvas as the digital equivalent of a sheet of paper. Creating a new canvas is easy. Just follow these steps:

1 Select **File ▸ New...** from the upper- left corner.

2 In the dialog box that appears, change both the width and height values to **32**.

3 Leave all other options as they are and click **OK**. A new tab will load next to the Home tab and will display the name *Sprite-0001*.

You've just created a blank canvas 32 pixels wide and 32 pixels tall. This screen might look a little intimidating because of all the buttons and options, but don't worry! By the end of this chapter, you'll be on your way to using Aseprite like a pro.

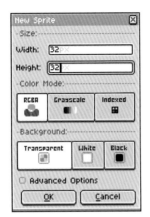

New Sprite dialog box

Blank canvas

Saving Your Work

Saving regularly is important to ensure none of your hard work is lost when something unexpected happens. Get in the habit of saving now so you do it automatically.

To save the canvas you just created, follow these steps:

1 On the menu at the top of the Aseprite window, select **File ▸ Save**. A Save File window will open and offer to save your newly created canvas with the filename *Sprite-0001*.

2 Change the file's name from *Sprite-0001* to *FirstSprite* in the File name field.

3 Click the **down arrow** next to the File type option. Select **png files** from the drop-down list.

4 Click **OK**, and your blank canvas will be saved as *FirstSprite.png*.

Aseprite will return you to the blank canvas tab, whose name will have changed from *Sprite-0001* to *FirstSprite. png*. Your 32×32 pixel canvas is now saved with that name.

From now on, just navigate to **File ▸ Save** or use the keyboard shortcut **CTRL–S** to save your work.

If you accidentally save your canvas with the wrong name or as something other than a *png*, don't worry—that's easy to fix. Simply select **File ▸ Save As...** and then follow the steps above.

Save your work often, and always use the *png* format, as it allows for the most flexibility when creating pixel art.

Opening Your Work

Once your canvas is saved, you can load it the next time you open Aseprite. Let's try reopening a file now.

Close the canvas you just saved by selecting **File ▸ Close** from the menu. You'll be back at the Home tab again. Notice that the Recent files area now has an entry called *FirstSprite.png* that also shows the file's location. If you move your mouse pointer over this entry, your pointer will change into a little pointing hand.

Click the *FirstSprite.png* entry, and your canvas will open.

Alternatively, select **File ▸ Open...** and click *FirstSprite.png* in the list of files and folders that appears. Then click **OK** at the bottom of the window to open your file.

As long as you save your work before closing Aseprite, you can reload your artwork, and it will look just the way you left it.

How Aseprite Is Organized

Understanding Aseprite's layout is important so you know how to access all the different tools when you're drawing.

Here's a screenshot of Aseprite with the different tools highlighted.

1 The *canvas* is where you draw. The alternating gray squares represent the drawing area, with each gray square being 16×16 pixels. The canvas in the screenshot is 2 squares wide and 2 squares deep, meaning it is 32×32 pixels.

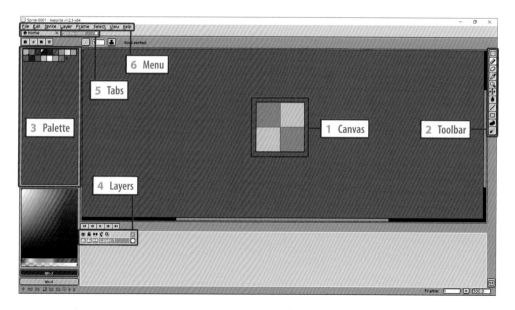

2 The *toolbar* is a set of 11 icons that offers convenient access to some of the most important drawing tools in Aseprite. We'll look at these tools in more detail later.

3 The *palette* is a grid of colors you can use when drawing. Below it is a color gradient area for selecting different colors. We'll discuss the palette at the end of this chapter and in more detail in Chapter 3.

4 On a computer, you can draw in *layers*. We'll see how layers work in more detail later in this chapter. These tools allow you to control the layers.

5 You may have several *tabs*. As you've already seen, you have a Home tab where you can access your recent files. Your tabs can also hold canvases so you can easily switch between the different pieces of pixel art you are working on.

6 The *menu* offers access to a range of features in Aseprite. We'll cover the most important features as we go through this chapter, focusing on the canvas and the toolbar for drawing. Don't worry about remembering everything now! You can always refer back to this chapter if you get stuck.

Toolbar Options

Aseprite's toolbar is part of its interface. You might not have heard the word *interface* before, but it's just a fancy word for the buttons, windows, toolbars, and menus in a piece of software.

One of the quirks of Aseprite's toolbar is that it hides multiple tools under one toolbar icon. For example, when you click the Pencil tool, you'll see two options appear: a Pencil and a Spray tool.

This is Aseprite's way of presenting lots of tools without cluttering the screen. Just remember that whatever icon you click becomes the active tool from the list and will remain visible on the toolbar when you click away.

Drawing toolbar

Moving Around the Canvas

Working on pixel art involves moving the canvas, and moving your canvas around involves using the Hand tool.

You'll find the Hand tool on Aseprite's toolbar, though you may have to click the Magnifying Glass tool to make it visible. Alternatively, you can press the **H** key, and the mouse icon will change to look like a hand. After selecting the Hand tool, you'll be able to move the canvas by holding down the left mouse button and dragging.

If you have a middle mouse button or mouse wheel, you can quickly access the Hand tool without even selecting it. Simply hold down the middle mouse button (or the mouse wheel), and the Hand tool will be activated until you release the button.

> **Note** The toolbar also has a Move tool below the Hand tool. The Move tool can move objects around on the canvas, but not the canvas itself.

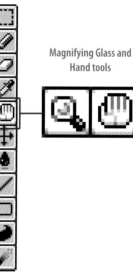

Magnifying Glass and Hand tools

Zooming In on the Canvas

To add detail to your artwork, you'll sometimes need to zoom in on the canvas. Zooming will always be centered on where your mouse pointer is. There are several ways to zoom in. Let's try zooming using three methods.

For the first method, you'll need a mouse with a scroll wheel. If you have this device, follow these steps:

1 With *FirstSprite.png* loaded, position your mouse pointer in the center of your canvas.

2 Scroll your mouse wheel forward (up) once. Aseprite will zoom in on the canvas.

3 Scroll your mouse wheel backward (down) once to make Aseprite zoom out.

4 Try scrolling several times forward and backward to see the levels of zoom that are available.

Zoom in, zoom out, and magnify

The second method of controlling the zoom uses your keyboard. Try pressing the **1**, **2**, **3**, **4**, **5**, and **6** keys to watch your canvas change between six levels of zoom.

For the last method, click the **Hand tool** on the toolbar to access the Magnifying Glass tool. Click the **Magnifying Glass tool** and then left-click the mouse on the canvas to zoom in. Right-click to zoom out.

In addition to zooming in and out, you can adjust your screen in various useful ways. When you press **Z**, three zoom options will be displayed just below the *FirstSprite .png* tab. Try clicking these options with your mouse:

- **100%** returns your canvas to its original size.
- **Center** recenters the canvas in the middle of the window without changing the zoom level.
- **Fit Screen** changes the level of zoom so that your canvas fits within the available screen space.

Zoom tools

Grid Locked: Working with a Grid

If you prefer to work in a neat and orderly manner, you might find having a *grid* of squares on your canvas useful. To show the grid in Aseprite, hold down **CTRL–'**. You'll see the grid appear as blue lines over your canvas. To disable the grid, repeat the same **CTRL–'** key combination. You can also enable or disable the grid from the menu by selecting **View ▸ Show ▸ Grid**.

Some programs even have subgrids, which are useful if you're making tiles that need to be the same size and will be used together (this is important when creating game levels). For example, you could have an area of 128×128 pixels broken down into a grid of 16×16 or 32×32 blocks. If you aren't happy with the size of the grid, you can easily change it by following these steps:

1. On the menu at the top of the Aseprite window, select **View ▸ Grid ▸ Grid Settings**. This will load the Grid Settings window.

2. The Width and Height values govern how big each grid square is in pixels. Set both the Width and Height values to **8** and click **OK**.

3. If your grid isn't visible, press **CTRL–'** to enable it. A grid of blue squares will be displayed over your canvas.

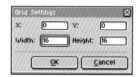

Grid Settings window

The other two options in the Grid Settings window are simply marked X and Y. These are *offset values* for the X and Y axes of the canvas. If both values are left at zero, Aseprite will draw the grid in perfect alignment with your canvas, so the first grid square will line up with the left and top edges of your canvas. If you increase either the X or Y offset value, the grid squares will be offset by the number of pixels you specify and won't line up with the canvas's edges. On the right is a 16×16 grid offset by 4 pixels on the X and Y axes.

You can also access a second grid option hidden in the View menu called the *Pixel Grid*. Unlike the main grid, which is blue, the Pixel Grid is sectioned into pixels and is a subtler background grid. To try it out, navigate to **View ▸ Show ▸ Pixel Grid** or press **CTRL-SHIFT-'** to toggle the grid on or off.

Drawing with the Pencil

The most basic drawing tool in pixel art software is the *Pencil tool*. In Aseprite, the Pencil can be selected by either pressing **B** or clicking the **Pencil tool** on the toolbar.

Let's try out the Pencil tool by creating our first piece of pixel art! Open the 32×32 *FirstSprite.png* canvas we created earlier. Enlarge the canvas window, zoom in, and enable the grid before continuing.

When you have the Pencil tool selected, you can place individual pixels by left-clicking the canvas. If you click and drag, you can draw freehand. Take some time to experiment and draw some circles, triangles, or even shapes of your own creation!

X/Y axes, offset 0/0 X/Y axes, offset 4/4

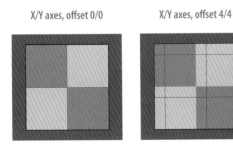

Pencil tool shapes

Erasing with the Eraser Tool

Art tools commonly have an *Eraser tool* that allows you to quickly make mistakes disappear, and Aseprite is no exception. Click the **Eraser tool** directly below the Pencil tool on the toolbar. Alternatively, you can activate the eraser by pressing **E**.

Eraser tool

When you select the Eraser, a field appears below the *FirstSprite .png* tab. This field will contain 8 px, which is the default Eraser size of 8×8 pixels. Click the field and change the value from 8 to **2** so the eraser shrinks to be 2×2 pixels.

Left-click and hold the mouse button while moving the Eraser over the canvas. You'll see parts of the shapes you drew in the last step disappear as you move the Eraser over them. You can also wipe the entire canvas clean in this way if you wish.

Eraser tool controls

Erasing shapes

If you ever accidentally erase something you didn't mean to, not all is lost! You can undo your accident. Find the undo feature in Aseprite under **Edit ▸ Undo**, or activate it by pressing **CTRL–Z**. Undo instantly reverses your last action. For example, if you draw a line with the Pencil tool and then press **CTRL–Z**, the line will disappear. You can also press **CTRL–Z** multiple times to undo more than one action.

Now what if you accidentally undo something you didn't mean to? This is also no problem. Press **CTRL–Y** to redo the action you undid.

Three other actions that will always be very useful when you are drawing or erasing pixel art are the *cut*, *copy*, and *paste* commands:

- To cut, use **CTRL–X**.
- To copy, use **CTRL–C**.
- To paste, use **CTRL–V**.

The cut and paste actions are typically used together. For example, if you have an area of the canvas selected, you can cut it by pressing **CTRL–X** and then paste it using **CTRL–V**. The cut action removes the selected area from the canvas. When you use paste, the selected area that was cut is added back to the canvas. This selection can be moved around, resized, or rotated.

The copy and paste actions are usually used together, too. Copying and pasting works just like the cut-and-paste example, but when you use copy, the selected area isn't removed from the canvas. When you paste it, you then have two of your selection.

Filling In Areas with the Paint Bucket

The Paint Bucket tool exists to perform one simple task: filling large, enclosed areas with one color. Think of using the Paint Bucket tool as pouring a bucket of paint on a surface that has a frame. The paint will spread until it reaches the frame, which stops the paint from spreading any further.

The Paint Bucket tool looks like a paint drop on the toolbar. You can click to select it or activate it by pressing **G**. A handy use for the Paint Bucket tool is to fill a new canvas entirely with some color you have selected. To do this, simply click anywhere on the canvas after selecting the Paint Bucket. If you have an area of the canvas that is completely enclosed, the Paint Bucket will fill only that area. For example, if you draw a square and click inside the square with the Paint Bucket tool, only the area inside the square will fill with the new color. This works with any enclosed shape. Try filling in the shapes you drew earlier to see how this works!

Make sure your shapes don't have any breaks, or they won't fill in the way you expected. For example, if your square has a gap in one of its sides, the Paint Bucket fill will spread the color outside the square.

Paint Bucket tool

Filled square

Spilled square

Selecting Colors with the Eyedropper

You can use the Eyedropper to select a color that is already on a canvas. For example, if you drew a red apple with a black outline on a green background, the Eyedropper tool would allow you to click the apple, the outline, or the background to select red, black, or green as the active color.

Eyedropper tool

In Aseprite, you can select the Eyedropper tool on the toolbar or activate it by pressing **I**.

Drawing Straight Lines

Sometimes, you'll want to draw straight or diagonal lines, which can be difficult when you're using the freehand Pencil tool. Try the *Line tool* instead, which you can activate on the toolbar or by pressing **L**.

Line tool

Using the Line tool, click and drag on the canvas to create a line. When you are happy with your line's length and orientation, release the mouse button, and the line will be formed. You can make completely straight lines or diagonal lines at different angles. If you want to make a straight line, press the **SHIFT** key while drawing the line.

By using the Line tool repeatedly, you can form shapes such as rectangles and triangles, but there are even easier ways to create common shapes in Aseprite.

Drawing Shapes

Below the Line tool on the toolbar is the Rectangle tool. Clicking the tool shows four options, which allow you to draw filled and unfilled rectangles and ellipses.

This is a powerful set of tools. The Rectangle and Filled Rectangle tools allow you to draw rectangles of any size. However, if you hold down the **SHIFT** key while drawing a rectangle, Aseprite will draw a square instead. The same is true of both ellipse tools, except when you hold down **SHIFT**, the shape will be a circle.

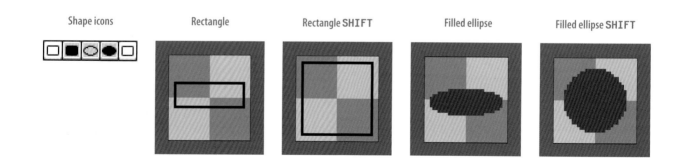

Shape icons Rectangle Rectangle **SHIFT** Filled ellipse Filled ellipse **SHIFT**

Layers

Drawing on a computer instead of a sheet of paper offers many advantages, and one of the most useful is access to *layers*. Layers are like lots of clear sheets of paper that you can draw on and then stack on top of each other to build up drawings. This allows you to split up your artwork into different elements and lay them on top of each other.

For example, imagine you want to design a character with different outfits. You could redraw the character as a new piece of pixel art for each new outfit. But with layers, you can draw the character once on a layer and draw each outfit as a layer on top of the character. This saves you time by easily allowing you to tweak the position of different parts of the outfits without worrying about accidentally changing the character wearing them.

When you create a new canvas, it only has one layer. You can see the layers on your canvas at the bottom of the screen. Each layer has several toggling options and a layer name.

Layer tools

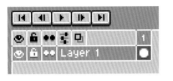

Layer 1 Layers 1 and 2

Here's a breakdown of what each part of the layer interface is called:

 Visible (eye icon) By clicking the eye, you can make a layer visible or invisible. This is useful for hiding details when you're working on more complex pixel art pieces.

Locked Clicking the padlock locks a layer to stop it from being modified. Click the padlock again to unlock the layer. This is very useful for preventing accidental editing of a completed layer.

Layer Name The name of each layer is shown next to the toggling options. The layer name defaults to "Layer" and a number, but you can rename your layers to make it easier to know what they contain.

You might have noticed we didn't talk about some of the options. The other tools are called Cels or Continuos. These are more advanced features, so we won't cover them in this book.

It's time to experiment! First, let's add some layers to a canvas.

1 Create a new canvas and save it as *Layers.ase*. When you use layers, you should use the *ase* format because *png* files merge layers when you save, which means any layer information is lost when you close your pixel art file. If you need a *png* file for a project, once you've finished making your pixel art, save your *ase* file and then select **File ▸ Save As a PNG** to save a copy of your pixel art as a *png*. By keeping the *ase* file, you can still change the layers in future.

2 Now we are going to add a second layer to the canvas. This can be achieved in two ways: using a shortcut or using a menu. The shortcut is quicker. To add a layer using the shortcut method, press **SHIFT–N**, and a new layer will appear called Layer 2.

3 Create a third layer using the menu method by clicking **Layer ▸ New Layer** from the menu at the top of the screen.

Creating a new layer

You now have a canvas consisting of three layers sitting on top of each other, just like three sheets of clear paper. The order of the layers is determined by where they are in the Layers Area list. The higher a layer is in the list, the higher it is on screen. Currently, Layer 3 should sit on top of Layer 2, which sits on top of Layer 1. When a new layer is added, it always sits on top of existing layers.

Whichever layer has a blue background is the currently selected and active layer, and inactive layers have a gray background.

Now let's have some fun drawing on the different layers we just created.

If Layer 1 isn't selected with a blue background, click Layer 1's gray background. This will turn it blue and make it the active layer.

1 Select the **Rectangle tool** from the toolbar and a **green color** from the palette in the upper left of the screen (we'll cover the palette more in Chapter 3). Draw a green square on the canvas and then select the **Paint Bucket tool** and fill the outline.

2 Click **Layer 2** to make it the active layer.

3 Select the **Rectangle tool** and a **blue color** from the palette. Draw a blue square on the canvas, and then select the **Paint Bucket tool** and fill it. Make the blue square partially overlap the green square you drew on Layer 1.

Layer 1 selected

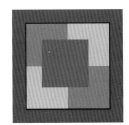

Layer 2 selected

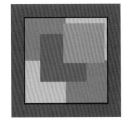

4 Click **Layer 3** to make it the active layer.

5 Select the **Rectangle tool** and a **red color** from the palette. Draw a red square on the canvas, and then select the **Paint Bucket tool** and fill it. Make the red square partially overlap either the green square you drew on Layer 1 or the blue square on Layer 2.

You should now have three squares on your canvas, with each one sitting on a separate layer.

The squares overlap so that parts of the squares aren't visible. If you drew these squares without using layers, the overlapping parts of the squares would be drawn over. You wouldn't be able to rearrange the order of the squares or separate them again.

With layers, however, you can rearrange the squares and move them without affecting the squares on the other layers. Let's see how this works by changing the order of the layers on the canvas:

1 Select **Layer 1** as the active layer.

2 Layer 1 will be blue with a yellow outline. Move your mouse over the yellow outline, and the pointer will change to signal the layer can be moved.

3 Left-click and drag Layer 1 up. Two inward-facing arrowheads will appear at the edges of the layer boxes.

4 Keep dragging Layer 1 up until those two arrowheads are between Layer 2 and Layer 3; then release the mouse.

Layer 3 selected

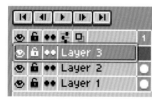

Layer 1 selected

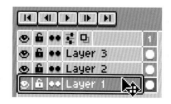

Layer 1 will now be above Layer 2 and below Layer 3. You'll notice the green square drawn on Layer 1 is now on top of the blue square you drew on Layer 2. This is because the squares exist on separate layers and are stacked on top of each other.

For example, in the outfit example you saw earlier, the character you want to give outfits to would be on the bottom layer of the layer stack. If you drew the character's pants on one layer and gave the character a long shirt on another, you could put the shirt layer under the pants layer so that the shirt looks like it's tucked in. If you switch the layers though, the character's shirt will be untucked!

Go ahead and try changing the layer order for Layer 2 and Layer 3, too. Layers give you lots of control over different parts of your pixel art, so use them to your advantage!

Box and Circle Selection

Box selection tools are used to select and move parts of your pixel art. In Aseprite, the box selection tool is called the Rectangular Marquee tool and is found at the very top of the toolbar or by pressing **M**.

The Rectangular Marquee tool can be a little hard to understand, but it's useful. Let's try it out:

1 Create a canvas that's 64×64 pixels.

2 Draw a filled box using the **Filled Rectangle tool** and a color of your choice. Make sure the box doesn't fill more than half of the canvas.

3 Select the **Rectangular Marquee tool**. Then click and drag inside your rectangle to create a *selection rectangle*. You can see the area you've selected by looking for a box of alternating dashed lines. Release the mouse button when you are happy with the size of your selection.

4 Click and drag the selection area to a clear part of the canvas. The selected area will move and leave behind a hole in the box you created.

Rectangular Marquee tool

5 Now that you've moved the selection, small white squares will appear around the selected area. These are used for resizing. Click and drag one of the small white squares to change the shape of the selected rectangle.

6 Now, resize the selection back to its original shape and move it back to fill the hole in the rectangle. Click anywhere on the canvas outside of the selected area to deselect it.

7 Select a new area inside the filled box you created.

8 Move your mouse pointer over the dashed line until a small dashed rectangle appears behind the pointer. Click the dashed line and drag. This will make the selection box move without moving the pixel art on the canvas underneath it. This is useful if you want to adjust which area of the canvas you have selected without changing what's on the canvas.

You don't have to select an area with a box. If you want, you can select a circular area with a circular shape tool. In Aseprite, the circular shape tool is called the Elliptical Marquee tool. You can find this tool as an option on the same toolbar icon as the Rectangular Marquee tool. Follow the Box Selection steps again, only this time using the Elliptical Marquee tool. You'll find they work in the same way.

Mirroring Images

Now that you know how to manipulate selected areas, as well as how to use the copy and paste features, it's time to start learning a useful technique for pixel artists: *mirroring images*.

If you need a character to be completely symmetrical, or just want to flip your image, you can select a piece of pixel art, copy it, and flip it. Let's try this out:

1 Create a canvas and draw a shape you would like to mirror.

2 Use the Rectangular Marquee tool to select your shape.

3 Press **CTRL-C** to copy the selected area, then **CTRL-V** to paste the copy of the shape onto the canvas. Now you have the original shape and the copy you made.

4 Drag the copy onto a free area of the canvas.

5 On the menu, select **Edit ▸ Flip Horizontal** (or press **SHIFT-H**). The flip will happen to the selected area, not the whole canvas as the name suggests.

6 Align the mirrored half to the original half of the shape you drew.

By using these steps, you can create mirrored versions of images.

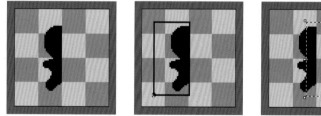

A Bit About Color

We'll be talking about using color in your art throughout the book. To get started, let's understand how colors are selected and used in Aseprite.

In the upper-left corner of Aseprite, you'll see a grid of different colors. This is called a *palette* (Aseprite calls this the Color Bar palette). The palette shows the colors you can use in your pixel art. Left-clicking any of these colors makes the color you selected the *foreground color*. The foreground color is the color used when you draw anything on the canvas with the left mouse button. Right-clicking any of the palette colors makes the color the *background color*, which is used when you draw anything on the canvas with the right mouse button. The selected foreground and background colors are displayed in the lower-left corner of Aseprite, below the color gradient area.

As an experiment, left-click a red color in the palette and right-click a blue color. Now, if you look in the lower-left corner, you'll see red in the upper color box (foreground) and blue in the lower color box (background). If you click either of these color boxes, a new window will appear, allowing you to change the color.

By using this system, you can have two colors readily available to use. If you want to replace one of those colors, simply right- or left-click a different color in the palette.

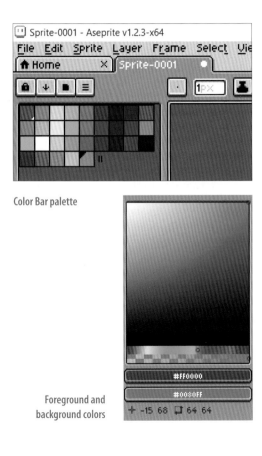

Color Bar palette

Foreground and background colors

You Are Ready!

Congratulations! You've learned about the tools you'll use and have the basic Aseprite skills you need to create pixel art. There are still quite a few skills you need to become a master pixel artist, but you'll continue to learn more about making pixel art throughout the book. If you forget how to access an Aseprite tool, we've also included a handy reference sheet in the appendix.

Now you're ready for the fun to really begin!

2

Shapes and Shading

Chapter 1 taught you the skills required to draw using your computer. Now, it's time to start drawing shapes and creating characters. In this chapter, you'll use shading to make your pixel art look more realistic! We'll start off with how to create basic shapes and add shading. Then, you'll learn how to combine shapes to make more complex art and how to break down shading into easier pieces. By the end of this chapter, you'll be creating and shading your own characters!

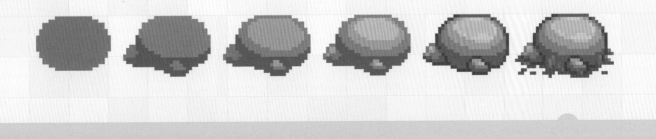

Silhouette Puppets

A good design starts with a great *silhouette*. A silhouette is a solid object filled with a single color.

A silhouette is important for making sure your pixel art design is recognizable. Think of your favorite characters and their silhouettes. You could probably recognize those characters from their outlines alone. Even using only the most basic information—just a shape—can create a memorable character.

Forming Basic Shapes

Draw silhouettes of basic shapes as a daily warm-up task. The best way to draw a shape is to use the click-and-drag method with the pen or pencil tool in your favorite art program.

Try drawing some silhouettes now! Start with a shape you're familiar with, like a heart or a star. After you've drawn your silhouette, take a good look at it. Is the shape recognizable? It's okay if it isn't at first. Just delete and redraw until you are happy with it. Practice makes perfect!

Silhouettes are extremely versatile and can be reused for many purposes. Silhouettes make for great inclusions in a pattern or as a shadow in a scene or video game, and we can do even more with them. In the next section, I'll show you how to turn your silhouette into a more lifelike character using shading.

Shading Outside the Lines

Using darker colors to depict shadows in artwork is known as *shading*. Shading makes objects appear more three-dimensional. When you're shading, think about how light would hit an object in the place you'd normally see it. Decide where the light is coming from and think about the angle at which it will hit your object. Then imagine where any shadows will fall on the other side from the light.

Whenever you want a character's final look to be affected by a light source, always start with the character's silhouette before adding lighting. Then build up your volume slowly, using as few colors as possible. Let's try shading a duck character as an example.

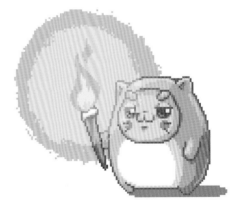

Shadow Me

For shading practice, you can download the base character from *https://nostarch.com/pixelart/* or come up with your own!

Once you have a basic character, you can start shading. We'll start out with a light source that's coming from the upper-right corner. Using a slightly lighter gray than the body color, draw over the areas where the light would hit. Most of the character's body should now be the lighter gray. The original color of the character will act as shadow under the arms and the lowest sections of the body.

Next, we need to work up the body and toward the light source, using ever lighter shades of gray. Choose a color of gray a shade lighter than the previous gray and draw a section of the body in that color. You can see the multiple gray sections in the third drawing of the duck, shown here.

As a final touch, you can draw a lighter circular patch on the character's head as a *highlight*, which represents the area the light strikes most directly. You can experiment with how many grays you use (we used three in this example), but be careful about using too many. If you have too many shades, the character will start to look fuzzy. Don't be scared to experiment! You can always use the undo feature to remove a few layers of shading.

You should now have a character that looks as though it is being hit by a light from the upper-right corner. As an experiment, try lighting the same character using a light source in the upper-left corner or lower-right corner.

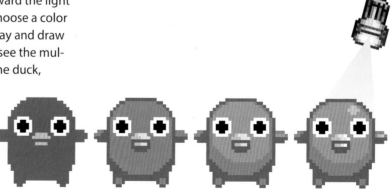

Experiment: Practice Basic Shading

Try shading the character on the left using the same light source for each example. If you have your light coming from the upper right, you should end up with something like the shaded character on the right. As you're shading, it might be helpful to think of the light source as a lamp and to draw the beam of light.

Psst! A handy reference guide to light sources is on the next page!

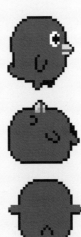

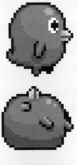

Using Primitives to Shade

Drawing basic shapes and imagining where shadows would fall on them can help you develop your shading technique. Basic shapes, such as cones, spheres, and boxes, are known as *primitives*.

Think about which surfaces the light would hit and which would be in shadow. Notice how each shape is shaded differently based on the location of the light source.

Once you know how to shade primitives, you can use this understanding to shade more complex shapes by imagining the primitives your piece is made up of. For example, our duck is really just a sphere that's been squeezed in the middle.

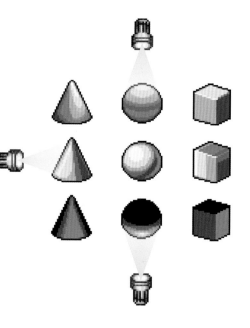

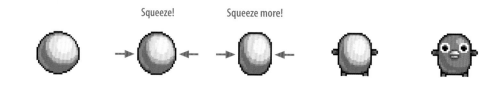

Squeeze! Squeeze more!

Combining Primitive Shapes

Simple shapes like primitives are not only great for beginners to practice with but are also fun for viewers. In fact, many of the most memorable game characters are just combinations of primitives. For example, Pac-Man is simply a circle with a section cut out, but the character remains one of the most memorable and regonizable in video games.

All of the objects in this section are lit using the same light source and contain the same sphere. They just connect other primitives to the sphere, and this gives them a completely different character. Notice how adding another shape can change how the light bounces off and around the sphere. Areas that might normally be hit by light might be shadowed by the other shape. The more complex your shapes are, the more complicated shading can become.

Sphere + sphere

Cone + sphere

Cube + sphere

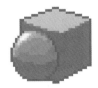

Experiment: Reduce, Reuse, Reimagine

Once you have a good handle on a variety of shapes and understand how they look when light hits them at different angles, you can reuse these shapes to create new objects and characters! Working step by step, use the basic shapes you saw earlier to create the objects you see on the right.

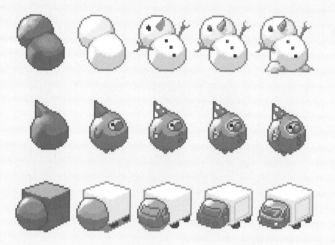

Once you're satisfied with the three complex shapes you've made, use them to create some brand-new objects. For example, the snowman shape could be somebody falling while looking scared, the party hat character could be a bird's head looking upward, and the truck could be a washing machine.

Experiment and create!

I'm a box now!

Shading Techniques

There are two main types of shading in pixel art: *flat shading* and *dithering*. These shading techniques will vary based on the lighting and material you draw, but you'll usually use only one technique at a time.

Shading techniques tend to use *gradients*, which are transitions between colors, shades, or levels of transparency on a graded scale. Many digital art packages have a dithering/gradient tool, which is definitely useful, but learning how to shade on your own is still worthwhile!

Flat Shading

The most common type of shading is flat shading. This involves stacking colors. The fewer colors you use, the crisper the object will appear. Clean lines and shapes are very important for this kind of shading, because if there are a lot of jagged edges and the object doesn't have a nice silhouette, you'll have a difficult time adding shading.

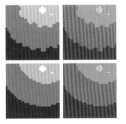

Although a crisp silhouette is important, the flat shading itself doesn't have to be crisp. We can incorporate chunky textures by varying the shadows' edges, as you can see in the top row of this example.

We have used flat shading in our examples so far.

Dither Me Timbers

Dithering involves creating a gradient, which is useful for imitating diffused lighting such as candlelight. It's also useful for creating see-through effects. For example, dithering would be the technique to use if you wanted to draw a veil over a face.

Dithering may sound complex, but it's really easy to achieve with a bit of pixel manipulation.

To see how dithering works, let's try an example. Using the Pencil or Pen tool, draw out four bars of the same color in different shades of darkness next to each other. Put the darkest at the bottom and the lightest at the top. For example, you could use four shades of gray or four shades of red. The color choice is up to you.

Select the color from the lowest, darkest bar (use the Eyedropper tool) and use that color to fill every alternating pixel in the first row of lighter pixels directly above the darkest bar. You should be left with a pattern that looks like the top of a castle wall.

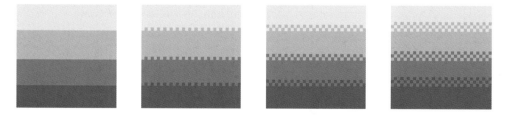

Dithering steps

Repeat that same process for the other bars. You'll get a simple dithering effect like the one in the second image on the previous page.

You can also use two or three lines of dithering, as in the third and fourth images on the previous page, but the same rule applies: only change the color of every other pixel per row. With multiple rows, offset the color change so you don't end up with lines. Once you've mastered this basic technique, you can try out other dithering patterns, such as triangles or other shapes.

As always, don't be afraid to experiment with patterns of your own or with colors.

Gradient pattern experiments

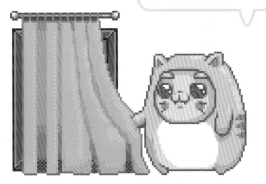

This curtain looks realistic thanks to dithering.

Experiment: Silhouettes to Shapes

Try turning these silhouettes into shapes that have volume by using flat shading and dithering.

Now, try interpreting the shapes in different ways by changing the direction of the light hitting them.

The Inside Is the Outside

Depending on your artistic needs, you may want a solid outline or an outline that is different shades in different places, based on where the light source is. This is especially useful for game backgrounds, because you'll sometimes need to soften the background to make foreground objects (like your characters) really pop.

Objects with softer outlines seem a bit out of focus, making them ideal for backgrounds.

If you want an object to pop, you can add a bolder outline. Here, I've added an outline around the same mountain in black, which brings it more into focus.

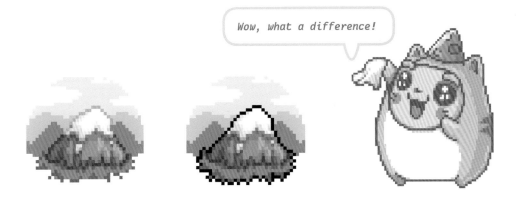

Wow, what a difference!

Imperfect Outlines

You can also make an outline look more natural by using selective coloring for different parts of the outline. When doing this, you still need to maintain a good contrast between the *midtone* (which is the base color) and the outline to make the pixel art pop out of the background.

For example, you can achieve a natural-looking outline in a few ways. In the left-hand image below, the shading creates an outline for the character. This can work well for a soft-looking image, but if you're animating a game character, it's important to have a crisp outline.

We've created a crisper outline in the right-hand image by adding a solid outline, but it's one that still factors in the light source. The outline is lighter on the top half of the character than it is on the bottom half. Even when using the same outline color around the entire character, factoring in how light affects the outline can enhance the overall look of the character and scene. As always, experiment until you are happy with the look of your art.

Pay attention to me!

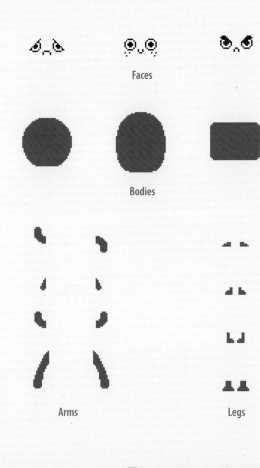

Faces

Bodies

Arms

Legs

Experiment: Value-able Characters

Now that you have the basics down, put together everything you've learned to design and shade your own characters. Download the pixel art files for this chapter from the book's website at *https://nostarch.com/pixelart/* and make your characters using the sheet of character parts. Mix and match the parts to make your own character, and then add your own shading, as you did with the duck at the beginning of this chapter! Try out flat shading and dithering, adding outlines, and making the characters your own.

Make as many characters as you like. Aim to create characters using each of the different body shapes, and make sure you're mixing and matching the arms, legs, and faces, too. Then, with a few of your favorite characters, explore the different ways you can make them look using shading and outlining.

Refer to Chapter 1 if you need a refresher on how to move the parts around using the selection tools in your pixel art software.

3

Colors and Palettes

By now, you should be used to drawing on your computer, working with primitives, using different types of shading, and creating your very own characters. But what those creations have lacked up to this point is color! In this chapter, we'll take that next colorful step.

You'll learn how to use color to add detail and sculpt characters. I'll explain how colors are broken down, what hex codes are, the different methods of coloring pixel art, and how to create and use color palettes. By the end of the chapter, you'll be using color to bring your characters to life.

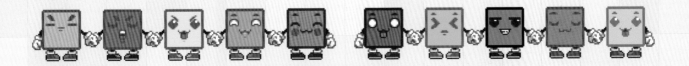

Forming Basic Shapes in Color

In the last chapter, we introduced silhouettes. Now it's time to draw them in color!

Load up your art tool of choice and select a color. We're going to draw a shape that will become a creature. First, draw the outline of this shape using the Pencil tool. Then, fill in the shape with the same color using the Paint Bucket tool. Don't forget you can use the Eraser tool to adjust the shape.

Adding Details

You can add details using different colors to turn your basic shape into a character. For example, if we add just a few colors in the right places, we can turn it into an elephant. Let's go through the transformation from green blob to elephant step by step!

First, look at some pictures of real elephants and identify their distinctive features. You might notice their eyes, ears, tails, trunks, and legs. Note where these features sit on an elephant's body.

Now, let's add these features to the green blob one at a time.

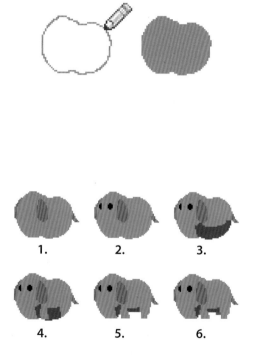

1. 2. 3.

4. 5. 6.

1 Pick a different color than your base color from the palette and draw some elephant features on your blob. Start with a little string of a tail and teardrop-shaped ears—partially hide one of the ears behind the elephant's head.

2 Choose black from your color picker and draw circles for the eyes. One eye will be partially hidden by the elephant's face, just like its ear, so draw over it in your base color to cover it. Remember, you can quickly reselect the body color by using the Eyedropper tool.

3 The belly of the elephant will be darker because it's in shadow. If your elephant's body is green, for instance, you should pick a darker green to create the shadow. To make the color darker, adjust it using the color gradient. Your elephant may look a little strange now, but you'll soon see why we drew it this way.

4 Using the same color as the elephant's body, add a front leg and back leg on the side of the elephant you can see clearly. You'll need to extend the back leg further than the shadow area. Think of it as making sure the elephant's back foot touches the ground to support all that weight! Don't worry about the other two legs just yet.

5 The elephant's belly needs to hang down between its legs, but it shouldn't touch the floor as it does now. Select the Eraser tool and give your elephant a tummy tuck by erasing between its legs. Also erase a bit of the shadow between the trunk and front leg.

6 The elephant is almost finished, but you've probably noticed that something is missing—a back leg that you should be able to see! Add this leg using a color that's slightly darker than the body color but lighter than the belly shadow. That way, it still looks like the leg is in shadow, but it's distinct from the belly and front leg colors. The second front leg is hidden from view behind the other leg and trunk, so you don't need to draw it.

Congratulations! You just sculpted an elephant from a green blob, and all it took was some more blobs of color and a bit of work with the Pencil and Eraser tools.

Creating random blobs and sculpting them into new animals can help you come up with unique creatures!

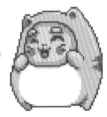

Experiment: Sculpting with Color

Try turning the basic shapes shown on the left below into the end result on the right using your own steps, the same way we made an elephant out of a blob. The files you need for this experiment are available for download on the book's website at *https://nostarch.com /pixelart/*.

Remember, we're just using simple colors and shapes here. The end result may look complicated, but by identifying shapes one by one and using different colors, you can build up complex details.

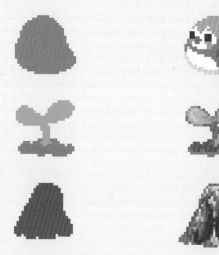

Spin Around the Spectrum

Colors are incredibly important to your pixel art. They can affect everything from how your art works in different contexts (such as in games) to what kind of mood your art conveys to the viewer.

Experiment with your colors!

Playing with Colors

Any given color is made up of a hue, saturation, and lightness.

Hue refers to the pigment of a color. For example, red, green, blue, purple, and pink are all hues. Regardless of whether you use a bright blue or a dark blue, they both share the same blue hue.

Saturation describes the intensity of a color. For example, a bright blue has a higher saturation than a pale blue does.

Finally, we have a color's *lightness* (also called *luminosity*), which is simply how light or dark a given color is. For example, you can have anything from a very light blue to a very dark blue.

Let's see how these three characteristics work together to make a particular color. The diagram on the left shows the relationship between these values and how changing each of them impacts the final color you'll get in Aseprite's color selector.

By adjusting these three simple aspects, you can generate millions of different colors. You can choose colors that exude confidence and passion or use cool colors with low saturation levels to convey a more relaxed and subdued scene. Let's see how simply changing the colors in the same piece of pixel art can change the mood of a scene.

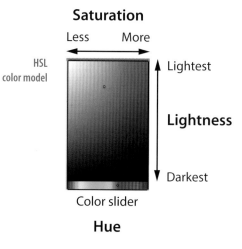

Being Moody

You don't have to be a master artist to get a message across! The human brain automatically perceives certain colors as threatening and others as calming. Use this to your advantage.

See how this scene's mood is altered by the change in color. These four scenes show how using different colors, or a lack of color, can convey different emotions to the viewer.

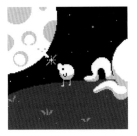

Stark

A scene without any color can convey desolation and anxiety. Everything could be fine, but until the viewer knows more, they might be suspicious that all is not well, thanks to the lack of color. Black and white can also be used to contextualize scenes. For example, you might use black and white to show scenes that occurred in the past.

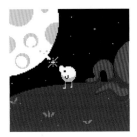

Stark with Danger

Using color sparingly can emphasize objects in a scene. By adding red to the otherwise colorless image, we've made the creature lurking on the right potentially very dangerous.

Mellow

In this version of the scene, the saturation of each color is similar, softening the scene and giving it a childlike quality. Because no one object stands out, the image appears mellow.

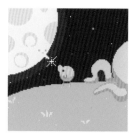

Vibrant

This color scheme is more game-like because the chosen colors allow all the important objects—the two characters—to stand out while looking right at home in the world. This is achieved by using colors that complement each other.

Make It Muddy

If you're working on game art, your sprite needs to be clearly visible against many background colors, so use a neutral background such as gray or brown as you're drawing.

By working on a neutral background, you can more easily keep track of when your art begins to lose contrast. If that happens, you can adjust your colors until your character pops out again!

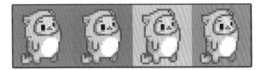

Using the right background color can solve problems before they happen!

Experiment: Stick in the Mud

Open your art program of choice and download this experiment's source file from *https://nostarch.com/pixelart/*. Then try filling these shapes with different colors to see which ones work best.

Experimenting with lots of colors is important because you'll better understand which colors work best with different backgrounds. Aim for colors that pop on the screen as much as possible, and note what works (and what doesn't).

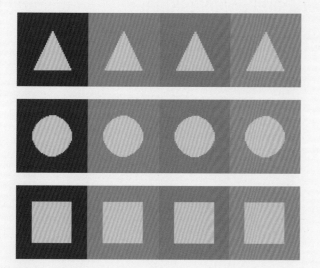

Choose Your Color Destiny

There are two main methods for coloring with pixels: the Eastern method and the Western method. With the *Eastern method*, you use techniques similar to those in traditional painting. You shift toward cooler hues for shading and shift toward warmer hues as shading gets lighter. With the *Western method*, you instead tend to keep the hue the same but add or remove white and black to make highlights and shadows. Whichever method you choose, keep this in mind when selecting what colors to use together.

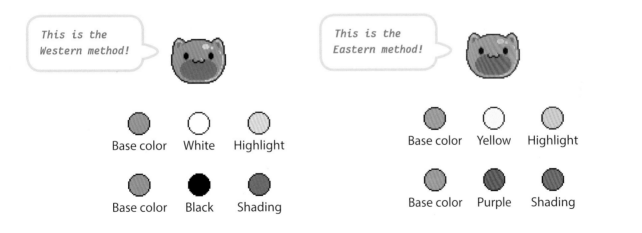

This is the Western method!

Base color White Highlight

Base color Black Shading

This is the Eastern method!

Base color Yellow Highlight

Base color Purple Shading

The Western Method

Although you can also increase or decrease the saturation, you'll focus mostly on how light or dark a shade to use rather than on saturation and hue when you use the Western method.

From left to right: outline, base color, shading, and highlight

The Eastern Method

The Eastern method is very similar to the Western method, but it requires an extra step when selecting shades of color.

When choosing darker shades, shift the hue slider toward the red/purple part of the spectrum and away from yellow/green. When choosing highlight colors, do the opposite: make the shade lighter and more yellow.

If you are at the end of the hue slider, the color might cut off, as the red does in Aseprite's slider. When this happens, simply go to the other side of the slider where the red continues, as we did in the rightmost panel in the below image. In some programs, the slider is a wheel rather than a straight line, so you won't run into this issue.

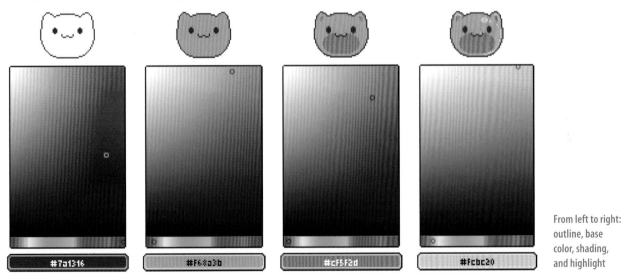

#7a1316 #F68a3b #cF5F2d #Fcbc20

From left to right: outline, base color, shading, and highlight

Experiment: Fill In the Blanks

Using a template can make it easier to pick colors for the Western and Eastern methods. On the left below is an example of both methods being used on the same blue base color. You'll notice that in the Western method, the shades become darker and lighter than the base, while in the Eastern method, the shades not only get darker and lighter but also get cooler and warmer, respectively.

Now try it yourself! Using your drawing program, draw the squares you see below and fill them using the Western and Eastern methods. Start with a base color that isn't too dark or too light in the middle squares. Then select lighter shades of the base color going to the right and darker shades going to the left.

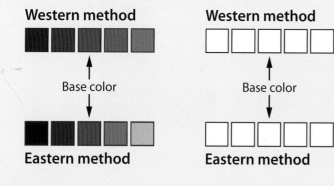

Western method

Base color

Eastern method

Western method

Base color

Eastern method

The Aseprite palette

Palettes and Swatches

We've learned a lot about color in this chapter, so now it's time to organize the colors you use. Let's discuss palettes and swatches!

A *palette* refers to all the available colors you can use in an art program. In modern computers, you have millions of colors to choose from!

But when you open a palette in an art program, you probably won't see all those colors. Instead, what you have is a *fixed palette*. To the right is a typical palette you might see when you first open an art program—in this case, Aseprite.

A fixed palette is a reduced set of colors taken from the full palette of available colors. When working with a fixed palette, you use only the colors it contains. Making palettes is an important part of pixel art creation because you'll likely reuse your palettes. Some art programs will give you a fixed palette to start with but also allow you to make your own. You could use 1 color, 10 colors, or 50 colors—it's completely up to you.

Each color in a palette is referred to as a *swatch*. So if you create a fixed palette of 10 colors, it would contain 10 swatches, and each swatch would be represented by a square box containing one of the colors.

In some cases, fixed palettes are necessary because of technical limitations. For example, the Nintendo Game Boy from the late 1980s had a monochrome display that could show only four shades of color. If you were creating art to mimic the Game Boy's style today, you'd create a fixed palette consisting of those four swatches.

Palette Ramps

Another term you might hear is *palette ramp*, which is simply a group of color swatches in your palette ordered by lightness. You can have more than one ramp per fixed palette, and each ramp can include a range of colors. The main reason for creating palette ramps is to maintain consistency. For example, you may want to create multiple pieces of art in the same style, or if you work with a team of artists and need to produce art for the same project, it's very important all the art uses consistent colors. Palette ramps are an easy way to achieve that.

16-color palette

32-color palette

Palette ramp

Making a Palette

Now that you understand the basics of palettes, it's time to create one! For this task, we'll use Aseprite as we did in Chapter 1, but the process of creating a palette should be very similar regardless of the art package you choose.

In Aseprite, you can find the palette on the left side of the screen. The active palette is represented as a grid of color boxes and a color selector, hue slider, opacity slider, and the active foreground and background color indicators below it.

When you create a new sprite in Aseprite, the default 32-color palette will be loaded. First, let's add a color to that palette.

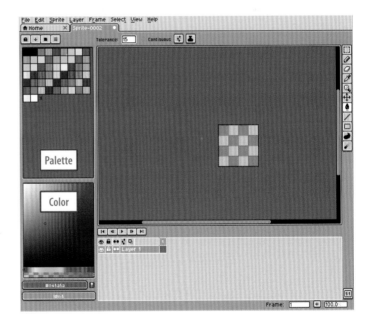

1 Create a new sprite.

2 Move your mouse over the color selector. The cursor should change to an eyedropper. Left-click anywhere in the color selector, and the foreground color box below the color selector will change to be that same color.

3 A red box with a white exclamation mark will appear next to the foreground color box. Click the **exclamation mark**, and the foreground color should be added to the palette as a new swatch.

4 Return to the color selector, but this time, left-click and drag your mouse over the hue selector. Notice how the color selector changes as you do so. Stop when you find a color you like, and repeat steps 2 and 3 to add this new color to the palette.

5 If you aren't happy with the colors you added or any of the existing default colors in the palette, you can remove them. Left-click the last swatch you added and press the **Delete** key to remove it.

Play around with your colors: use the color selector and hue slider to adjust colors, add new colors to a palette, and remove colors to create your own unique palette.

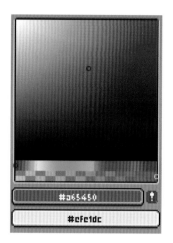

Adding a new swatch

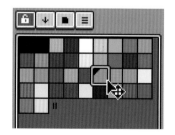

Selecting a swatch

Saving and Loading Your Palette

Once you're happy with your palette colors, you can save the palette for future use by following these steps:

Palette icons

1 You should see a row of four icons above the palette, like the ones shown here. Click the **Options** icon, which should be on the right and looks like three horizontal lines.

2 On the menu that appears, click **Save Palette**. This will open a dialog where you can choose a name for your new palette. Give your new palette a name that evokes the colors it contains so you'll recognize it later when you may have several saved palettes. Once you've entered a name, click **OK**. The palette should now be saved as a *.ase* file.

Loading a saved palette is simple: just click the **Options** icon, click **Load Palette**, and select the *ase* file that contains the palette you created. If you want this palette to load for all new sprites, you can also set it as the default palette. To do this, follow the same instructions as when you save a palette, but instead of Save Palette, choose **Save as Default Palette**.

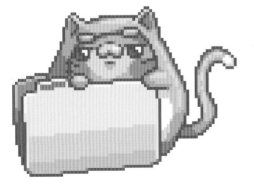

Restricted Color Comparisons

While you're unlikely to have restrictions on your palette on modern computers, purposefully restricting palettes is a popular style choice to set a mood or get a retro look. For fun and practice, many artists choose to use palettes of famous games or gaming systems such as the Game Boy, which we mentioned earlier. Let's see what this little traveler would look like with various restricted color palettes.

The fewer colors in your palette, the more creative you'll have to be. For example, in the 8-color image, the top of the backpack and the shading on the skin are actually the same color, but careful placement makes it appear as though we're using more colors. When we get down to having two colors, we have to rely almost entirely on dithering to show lighting. Outlines also become more important when you have only two colors, and you'll need to invert some colors to keep contrast. For example, the twine holding the traveler's pots is white in the two-color image but a dark shade in all the other palettes.

From left to right: full color, 16 colors, 8 colors, and 2 colors

Experiment: Restricted-Color Cat

Below, we have a well-dressed business cat in full color alongside three line-art versions of the same cat. Try re-creating business cat's look using 16-color, 8-color, and 2-color palettes. Download the three restricted-color palettes and the business cat sprite at *https://nostarch.com/pixelart/*. Import each palette into Aseprite, load the sprite, and get coloring!

Full Color

16 Colors

8 Colors

2 Colors

Feeling squeezed by color restrictions? Use dithering to transition between colors.

Creating a Palette from an Image

If you already have a sprite, you can load it into Aseprite and save the palette that Aseprite creates from the image.

If you want to experiment on a blank canvas, you can also save the palette you make from scratch. Use the color selector to pick colors and then draw with them. When you are done, select the **Options** icon and click **Create Palette from Current Sprite**. This will create a palette containing all the colors you just used on the canvas.

Hex Codes

Finally, let's talk about *hex codes* and how they relate to palettes. Hex codes are a way of describing a color as a code. Every color swatch is represented by a code written in *hexadecimal* (*hex* for short), which is a number system that uses the numbers 0 to 9 and the letters of the alphabet A through F. Each hex code is written beginning with a # followed by six digits, like this:

The first two digits represent the intensity of red, the second two the intensity of green, and the last two the intensity of blue. This mix creates the final color you see, just like mixing shades of red, green, and blue paint would create a specific color.

The intensity of each color in hex can range from 00 (no intensity) to FF (full intensity). If you're wondering why the intensity goes up to FF, it's because hex numbers work a little differently than the numbers we usually use.

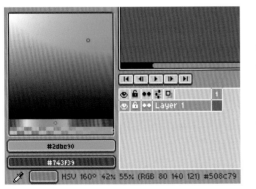

Foreground and background color hex codes

We're used to seeing *decimal numbers* that only use the digits 0 to 9 to count. When we reach a number above 9 in decimal, we carry the 1. For example, we go from 9 to the number 10, then 11, 12, 13, and so on. In hex, however, you use the first six letters of the alphabet to count above 9, so instead of counting from 9 to 10, you count from 9 to A, then B, C, D, E, and F. When you need to count above F, you carry the 1 as you would in decimal. That means the decimal number 16 is actually 10 in hexadecimal.

Some simple examples of colors and their corresponding hex codes are black, #000000, and white, #FFFFFF. Black is all three colors (red, green, and blue) at their lowest intensity. White is all three colors at their highest intensity. If you want to see how the hex value changes as you choose different colors, just load up Aseprite and start moving your mouse around the color selector. You'll see the hex value of each color on the status bar at the bottom of the Aseprite window.

It can be difficult to understand at first how hex codes work and how you can turn them into RGB values, so we've gone into even more detail in the appendix at the back of the book, which also doubles as a hex code cheat sheet!

"Talent is a pursued interest. Anything that you're willing to practice, you can do." —Painter Bob Ross

Experiment: Practice Coloring Methods

Now that you know how to create your own palettes, try choosing colors for several objects using both the Western and Eastern methods. Experimenting with applying colors to these characters will help you better understand both methods and discover which method works best for you. If neither method fits your style, be bold and come up with your own! Download this experiment's source file at *https://nostarch.com/pixelart/*.

4

From Concept to Complete

By the end of this book, you'll be confident creating art on a computer, but to make art you're happy with, you first need to know how to plan out what you're going to draw.

Getting your ideas down on "paper," whether physical or digital, will really help. Drawing allows you to refine an idea, fix mistakes, and add details you hadn't thought about before.

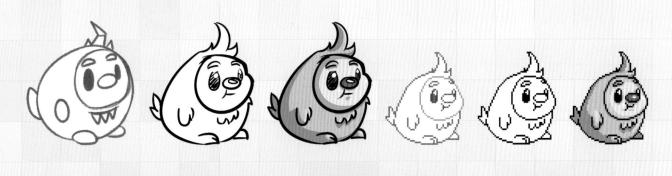

Sketching

While you can create pixel art without making a sketch first, starting with a sketch is usually very helpful for developing an idea more fully and saving time later on. Time spent sketching is never wasted time!

Since sketches are just references, they can be as messy as you like. Perfection is not the point here. Get your basic idea down and don't worry about cleaning up your art—at least initially. Sketching is also how artists brainstorm and practice to improve their art, which is why many artists carry a sketchbook around.

If you prefer to sketch on paper using a pen or pencil, digitizing your sketch is as simple as snapping a photo of your paper with your phone's camera, as we did with the pencil sketch here. Before we get into technological details, let's go over some drawing tips.

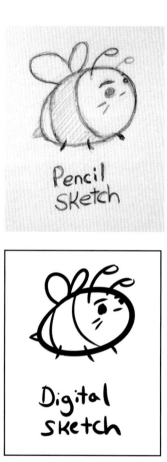

Pencil Sketch

Digital sketch

Drawing Perspective

Drawings are simply combinations of two-dimensional (2D) shapes made to represent two-dimensional or three-dimensional (3D) objects. Because 2D shapes are flat in real life and on the page, they are relatively easy to draw, just like the square, circle, and triangle below.

You can't really create a 3D object on a 2D piece of paper, so you need to construct the illusion of three dimensions. You can do that using *perspective*! There are three common types of perspective: *one-point*, *two-point*, and *three-point* perspective. Let's see some examples of these using a cube.

One-point perspective **Two-point perspective** **Three-point perspective**

Here, we've drawn the same cube three times to show each type of perspective. In each case, lines coming from one or more *vanishing points (VPs)* act as guides for drawing the sides of the cube. When you draw a 3D object, pick a perspective, draw your vanishing points and guide lines, and then draw the object within them.

Keep this technique in mind when you try to draw anything 3D, be it an object, character, or even a whole scene. Using vanishing points may look complicated, but once you do it a few times, it will feel natural.

A Circle or a Sphere?

Sometimes you'll draw a 3D object that looks the same all the way around, no matter how you turn it. A good example is a sphere. For an object like this, use the shading techniques we covered in Chapter 2 to show that the object has depth. When you draw a 3D object viewed from the front or an object that doesn't have an obvious depth, you'll need to use shading techniques.

Study how light reflects off an object and what parts of the object block light. Use this knowledge to create realistic objects!

3D Takes Work!

It can be difficult to draw 3D shapes, but if you practice every day and break objects down into primitives, you will be able to draw anything. Practice drawing objects from your environment, but also learn how to make objects that don't already exist. This is how you create new characters!

You might have a talented friend or have seen an artist who seems to do everything freehand and only from an outline, but all artists use shapes to construct things—some artists just mentally picture the shapes they need to construct an object. Don't feel discouraged if you have to use rulers or measure things out. In fact, you should do those things!

Warm Up the Happy Way

Don't worry about your skill level—the important thing is that you draw every day. Even if you only have 10 minutes to spare, do a drawing exercise. Practice makes better!

When you're first starting out, put time into doing quick exercises rather than trying to create pieces that take a really long time. By churning out more drawings, you'll get more practice and improve faster.

Doodling whatever comes into your head, or just drawing lines and circles, can help your muscle memory. It's also a great way to warm up. Train your hand-eye coordination by drawing the same shape repeatedly. Retrace lines over and over again until you get a steady line and know what speed your body needs to move to draw clean lines.

Perfect your circles, lines, and squares, but don't forget about odd shapes, too. Drawing irregularly shaped things like beans and water balloons can help train your brain for more complex shapes like a human bean (being!).

Avoid the Wiggle

A mistake people often make when they first start drawing is going so slowly that their lines end up wiggly like this:

This is sometimes called *chicken scratch* or *chicken steps*. While drawing slowly and carefully might seem like a good idea, your lines will end up looking uncertain. Build your confidence by drawing lines briskly so they come out straight and true. Also, don't get attached to one drawing and labor over it to the point of frustration. If a drawing isn't coming out the way you want, that's okay! Just start again fresh or draw something else. Even the best artists have bad days, and you're going to make lots of mistakes starting out. Eventually, you'll be able to quickly and smoothly draw the lines you want.

Section It Off

To warm your brain up to seeing in three dimensions, add *contour lines* to your 2D drawings. Contour lines help you shade your 2D drawing so it looks 3D. To make contour lines:

1 Sketch a shape or object in 2D.

2 Draw a line through the object's center.

3 Now, draw lines across the center line as though they are strings that you're wrapping around the object and pulling tight, like with this meat-on-a-bone character. Think of how the strings would curve around the object and slide into position.

You'll end up with a 2D drawing that looks like it has more depth. Plus, you should have an easier time shading the object because you'll be able to see where the light would fall and where the object would be in shadow.

Lights! Camera! Thumbnails!

If you're planning to draw a big, complicated scene, it can be helpful to create small, simple representations of your final work. These are called *thumbnails*, because you're forced to reduce the complexity of your scene to fit inside a very small area—like the size of your thumbnail!

Draw the shape that will contain your image first so that you're working within the frame and considering it when drawing. It's rare to get things right on the first try, so make lots of thumbnails before attempting a big drawing!

Seeing for the First Time

Filling your mental memory with objects is important. While you might think you know what an apple looks like, until you sit down and study it, you likely won't remember enough detail to draw one from memory.

Game artists use references for things they don't know how to draw yet, and they keep a collection of references in case they need help or forget how an object looks. Think of every drawing reference as a tool you put inside your mental toolbox that you can take out later. If you want to start a drawing or art project, first collect references.

When using a reference, break down what you're looking at into shapes that are much smaller. In Chapter 3, this is what we did when creating the elephant sketch. Start with the most basic shape or "body" of the reference and add details slowly.

There's no time like the present to try this out. Find a piece of fruit and draw it as a reference. Don't have any fruit? Try a vegetable! Think of other everyday objects you'd like to draw and start building up your own collection of references.

Apple drawn without a reference

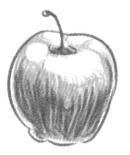

Apple drawn with a reference

Some games even use sized-down 3D models to look more like pixel art or 3D models with pixel art textures.

A 3-Bee Reference

Sometimes your art will need to stick to a very precise perspective. It can help to mock up the simple shapes of objects you are going to draw in a 3D modeling program. For example, you could download and try the free-to-use Blender. Learning to use one of these programs, even just the basics, helps not only with making shapes but also when experimenting with light sources.

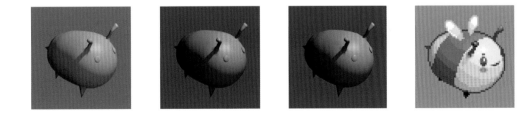

From Sketches to Pixel Art

Now that you've learned about sketching, you might be wondering how we go about converting pencil or digital drawings into pixel art.

One decision you'll need to make is how to make your drawing the size it needs to be for your pixel art project. Your options are to redraw the whole piece by looking at the reference sketch or to resize the drawing to the size you want the sprite to be. If you have trouble visualizing an object as being much smaller, you might want to try resizing your sketch.

Resizing and Results

Each art program will have different options for resizing art, but to keep things simple, we'll focus on two options: *bilinear* and *nearest neighbor* resizing.

Bilinear resizing reduces distortion by taking into account the colors surrounding each point in your drawing, but nearest neighbor resizing is simpler and faster. You can use bilinear resizing for your non–pixel art sketches. When you want to resize your pixel art, you should use nearest neighbor resizing.

When using nearest neighbor, doubling or halving the size usually works well, but resizing by other percentages can cause problems. Always check your art after resizing. And remember: you can always undo a resize and try again!

Here is what a bee sketch and the same bee in pixel art look like resized using bilinear and nearest neighbor resizing, respectively. Experiment with each resizing technique to see how it impacts your art.

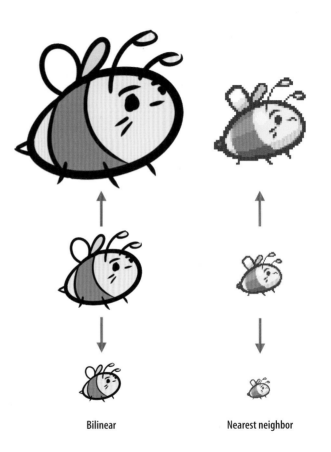

Bilinear Nearest neighbor

Layer It Up

Once you've resized your drawing, you can open your sketch in a pixel art program and simply draw over the sketch on a new layer. We covered how to use layers in Aseprite in Chapter 1, but now let's see the power of layers when you use them with your sketches!

Imagine if you could instantly turn any piece of paper into tracing paper, then back into a normal piece of paper when you were done tracing. You can do that by making your sketch a layer in your pixel art. Trace over your sketch on another layer. When you want to look at just your pixel art, you can make the sketch layer invisible. Clean and simple designs work best for this technique, as you can always add more details later! As you can see here, we use layers to draw over the bee sketch and grab the important details for our pixel art.

To turn a resized reference sketch into pixel art, we have to pull out the details bit by bit. We've used different colors to show the main details that form the pixel art version of the sketch. Remember that we're trying to simplify the drawing. So some details will have to be omitted, or the pixel art will become too complicated, defeating the purpose.

Using drawings as references, especially if you're planning to layer your pixel art over the top, can help produce more interesting and varied lines.

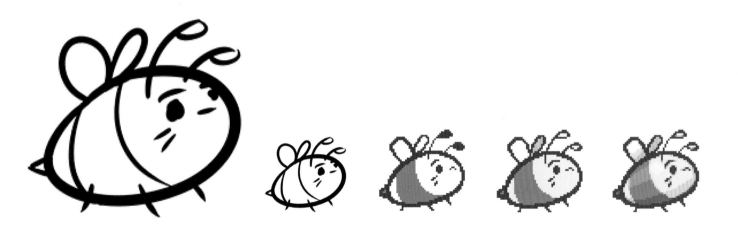

Experiment: Sketch it!

Try re-creating a smaller version of a drawing you've already made (or create a new one if you prefer). Don't resize the image at this point—just use the drawing as a reference.

Challenge yourself to simplify the drawing by keeping your file width and height no larger than 64×64 pixels. After you've tried re-creating your drawing without resizing tools, try shrinking the same drawing and using layers to draw your pixel art. Look at the differences between each piece of art and think about which method you like better.

 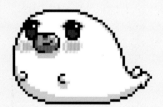

Balancing Act

When you stand, you almost always have at least a little more weight on one foot than the other. Standing with your weight evenly balanced on your two legs requires conscious effort, and if you stand in one place for very long, it's natural to shift back and forth, adjusting your weight to stay comfortable.

Your two-legged pixel art characters, even if they're just standing still, will also invariably end up putting more weight on one leg than the other. When you draw a character (or an object), it's important to give it believable posture so the character doesn't look as though it should tip over.

As you draw pixel art, you may have a difficult time seeing imbalances and mistakes, but these can be revealed simply by flipping your art horizontally! To do this, use the Flip Horizontal feature that most art programs include. You can go back to Chapter 1 for instructions on how to use Aseprite's image-flipping tools.

You can see flipping in action on this eggplant. As if by magic, this sassy eggplant's imbalance becomes apparent just from flipping the image. He would most certainly tip over if left unattended.

To fix the imbalance, I redrew the eggplant so it looks like it's carrying more weight on its right side. By doing so, he no longer appears like he'd tip over when flipped!

Keep flipping your art occasionally as you work. Checking for imbalance will eventually become second nature, and you'll identify and solve balance problems quickly.

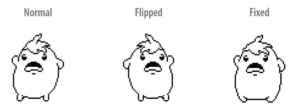

Normal Flipped Fixed

Getting a Better Edge

Sketches can and will be messy as you develop your idea. That's perfectly fine. However, unless that's the final result you're going for, you'll need to clean up those lines! If the lines aren't right, making your pixel art believable becomes a lot more difficult.

Your pixel sketch can start off very messy, like the octopus image below. As you chip away and refine your lines, you'll start to see the problems in the outline; your sketch won't always translate to the finished product. Just keep redrawing parts that don't look right. Zoom in and out as you work to see your art at different sizes and to get a close-up look at your lines.

Try to avoid jagged edges, since they rarely look good. You may also make your lines thicker as a style choice, but you must be consistent.

Rules are good to start with, but don't be afraid to try new things!

Don't Be Too Edgy

Straight lines are great for drawing a freshly milled steel cube, but they rarely occur in nature. Be aware of this when you're working on your outlines.

Style preferences aside, the octopus looks more natural with smooth curves than boxy edges. To shade your art nicely, you need to start with good line art.

Zooming in and out as you edit line art will help you see flaws.

Experiment: Fix Me Up

Download the mushroom image on the left from *https://nostarch.com/pixelart/*. Try making it look like the one on the right by smoothing out the jagged edges. Erase any areas that don't look right, and redraw them.

Always look for ways to improve your lines. There are many ways the mushroom could be drawn, and your own style of drawing will impact its overall look. What things would you do to improve it? Experiment!

Double-Wide Lines

We can use thicker lines for the outline of a character and thinner lines for the details to get a paper-cutout look or to enhance the smaller details of a drawing. For example, this dog is drawn using a thick outline but with thinner lines for the detail on the face.

Sometimes you'll want to mix and match line thicknesses. For example, even though the ear on this dog is a detail and not part of its outline, I decided to draw it with a thicker line. This makes the character look more 3D. Try drawing the ear with a thinner line, and you'll instantly notice the difference.

An easy way to practice this style of drawing is to get a thick marker and a standard writing pen. Draw the outline of some characters with the marker and then add the details with the writing pen.

Experiment: The Fungi and the Line

I've drawn our mushroom using only thin lines. Try redrawing it with a thick outline and then add the details using thinner lines. Once you're happy with your creation, try coloring and shading it, too!

Were you expecting a mushroom pun? Well, too bad, because I have morels!

5

Get in the Game

Art for video games can be broken down into two distinct parts: the environments and the characters. This seems simple enough, but you'll need to take a lot of other factors into consideration, too. For example, if you create a game with levels, you'll need to think about how to create art that can be reused, and you'll need to make characters that are easily recognizable even when animated and drawn in different sizes.

By the end of this chapter, you'll know how to do both these things and more. Let's start by seeing how we can set and change the mood of a scene using colors.

Harmonizing the Colors

Every pixel art scene you create needs a mood, and an easy way to set a mood is to harmonize all the colors in a scene. For example, you could adjust the colors in your game depending on the time of day. At night, all the colors may shift toward black, and objects may become less saturated the further they are from light sources. Many artists use a simpler palette and dithering to convey how a scene looks to us at night when we can't see as many details.

The two images here show a daytime scene and the same scene at night. When you change the mood of a scene, you don't have to start from scratch! You can turn day into night with the power of Aseprite!

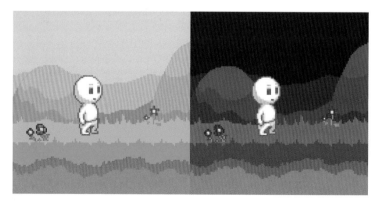

Recoloring a Background with Aseprite

We'll use Aseprite's *Magic Wand tool* to change the colors of a scene from day to night. The Magic Wand allows you to select areas of the canvas that are made of similar colors. By default, the Magic Wand's *Tolerance* is set to 0, meaning it selects areas containing only one color. However, if you want the Magic Wand to select other similar colors, you can adjust its Tolerance. The Tolerance appears just below the tabs in the Aseprite window when the Magic Wand is selected.

Magic Wand tool

Download the daytime scene from *https://nostarch .com/pixelart/* and load the file into Aseprite. Then follow these instructions:

1. Click the **Rectangular Marquee** tool and select the **Magic Wand** tool from the options that appear.

2. Click the lightest part of the sky with the Magic Wand to select it.

3. Select the **Eyedropper** tool from the toolbar and click the blue color inside the selected area. This will change Aseprite's active foreground color to match.

4. In the color selector below the palette, move the circle down toward the darker colors until you find a color you like.

5. Select the **Paint Bucket** tool on the toolbar, click inside the selected sky area, and the light blue color will be replaced with the darker color you chose.

6. Press **ESC** or click outside the canvas to clear the selection.

We've changed one color in the scene, but we've still got a lot to go! Let's learn a few more tricks that will make recoloring the scene easier.

Selecting the sky with the Magic Wand

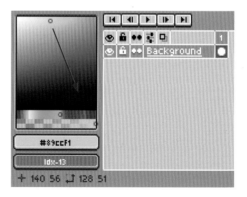

Drag toward darker blues

Selecting Multiple Areas

The next part of the sky is split into three sections: there's some between the rock and the left side of the screen, a little between the rock and the character's head, and more to the right of the character. Therefore, we need to select multiple areas using the Magic Wand. Luckily, Aseprite makes doing this easy! We'll learn how to color the sky using two different techniques. For both methods, you'll first select the Magic Wand tool from the toolbar.

- Method 1: Hold down **SHIFT** and then click the three areas of sky. By using this method, you can select any areas, even if they aren't all the same color. Now, deselect the sky to try the second method.

- Method 2: This method is quicker, but it only lets you select areas of similar colors. With the Magic Wand tool still selected, untick the **Contiguous** option next to the Tolerance box. Now if you click any of the three areas, they will all be selected automatically.

Next, we'll color this part of the sky a darker color:

1 Select the **Eyedropper** tool and click the blue inside one of the selected areas. Then use the color selector to find a darker color.

2 Select the **Paint Bucket** tool, untick the **Contiguous** box, and click one of the areas of sky. When you do this, all three of the selected areas will change color with one click.

Finish up the scene by darkening the rest of the colors. When it comes to pixel art, there aren't right or wrong colors. Each artist will end up creating a slightly different night scene, so just keep experimenting until you're happy with the result!

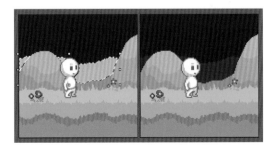

Playing with the Magic Wand's Tolerance

In some cases, the Magic Wand might not select an area as you intended. This happens when the colors within the area vary slightly. You can solve this problem by adjusting the Magic Wand's Tolerance.

For example, if the Magic Wand tolerance is set to 0 and you click a green area, only the pixels sharing that exact green will be selected. The higher the tolerance value, the less sensitive the Magic Wand becomes to color. If you increase the tolerance to 10, you'll be able to select areas that are similar shades of green, but you wouldn't select red areas, for instance.

Let's see how this works through an example. Download the image on this page from *https://nostarch.com/pixelart/* and load it in Aseprite.

1 Select the **Magic Wand** tool, set the Tolerance to **0**, and click the darkest green that surrounds both circles. Neither circle should be selected.

2 Now, deselect the area by clicking outside the image, and increase the Magic Wand Tolerance to **15**.

3 Click the darkest green again, and you should see that one of the circles is also selected. The sensitivity of the Magic Wand has been lowered enough to allow that green to also be selected, but not the lightest green.

The Tolerance you set will depend on the image's colors. Change the Tolerance in small increments until the Magic Wand is picking the areas you want to change.

Tolerance 0

Neither circle selected

Tolerance 15

Darker circle selected at tolerance 15

Lighter circle remains unselected

Background vs. Foreground

In addition to using color to control a scene's mood, you can control how close an object appears by tweaking its color saturation. This holds true for an object's outline, too. In fact, changing the outline is the easiest way to bring an object into focus or deemphasize it. The thicker and darker the outline, the more an object will pop out of the scene, and the closer it will appear. Look at how you can make either the character or the background the focus of the scene just by adding a thicker and darker outline.

When you're designing art for games, you want only the important parts of a scene to pop out. If all your objects use the same color saturation and outlines, your scene can look very flat. Fortunately, you can prevent this by using less saturated colors for objects that are further away and increasing the saturation for objects that are closer to the viewer. In this way, objects that are further away appear less vivid, meaning they lose some color intensity and brightness.

No focus

Character focus

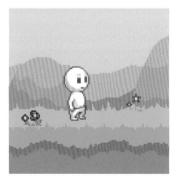

Background focus

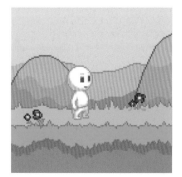

Details and Distance

In real life, you see less detail when you look at something far away, and in your pixel art, things that are far from the viewer should have fewer details. When you need to create objects at different distances, it's best to make your pixel art in its largest, most detailed form first. Removing detail as your art gets smaller is much easier than adding it as your art gets bigger.

Remember to tweak the colors in your art, too. Notice that the smallest version of the building has less vivid colors than the two larger versions. Let's look at how to tweak colors in more detail.

A Foggy Encounter

You need to adjust the color of your objects with distance consistently across all the objects that appear within a scene. An easy way to manage this is to pretend the object is standing in fog. The further away an object is, the more *opaque* (the more solid looking) the fog becomes, and the duller the colors of the object appear.

The easiest way to convey increasing distance is to lower the saturation of the color palette. Let's do this with the traveler sprite, which you can download from *https://nostarch.com/pixelart/*.

Once you have the traveler sprite open in Aseprite, follow these steps:

1 You have the full-size character, so now you need to create smaller versions of him. You can either draw these smaller versions or copy the full-size drawing twice and resize it. If you choose to resize rather than redraw, some of the character's detail will be lost.

2 Add a new layer to the canvas that sits on top of the character layer.

3 In the new layer, create a box large enough to cover the middle-sized character and set the box's fill color to gray.

4 Double-click the second layer's name to bring up the Layer Properties.

5 Click and drag the opacity slider from 255 to as close to **102** as possible. Why 102? To get the desired effect, 40 percent opacity will work well, and 40 percent of 255 is 102.

6 Position the now partially transparent box over the middle-sized character.

7 Repeat steps 2 to 6 using a third layer. This time, create a box at 80 percent opacity for the smallest character. That means you need to set the opacity slider to **204** (255 × 0.8) to create a much thicker fog for the character to stand behind.

Now you should have three sizes of the same character at different distances!

Original, no fog

40 percent opacity

80 percent opacity

Experiment: Beep Beep!

Draw this delivery truck as it gets further away. To make it easier for you to focus on conveying distance, we've kept this drawing simple, with a thick outline and no shading. Think about removing details and making the colors less saturated as the truck gets further away. Start by drawing the truck at its largest size, and then make it smaller.

Consider making the truck's outlines thinner as it gets further away—or even removing them entirely at the furthest distance. Text is one of the first details that will disappear, so don't worry about getting that part perfect—it's not supposed to be!

A tileset

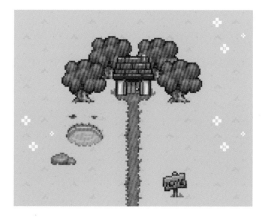

A scene created using the tileset

Tiling and Tilesets

If you're working on video games, you'll likely need to create *tilesets*. A tileset is a grid of tiles that each contain pixel art. You can use tilesets to create layouts for different levels in your game, backgrounds, machinery, or even modular enemies!

The scene here is created from the tileset on the left. You'll notice that we reuse a number of the tiles in the scene. Even though the tileset only has one copy of each tile, you can use individual tiles as many times as you want. For example, if you have a grass tile, you can use it repeatedly to create a large lawn. You can use a dirt tile to form a path or trees to create a grove.

You've probably noticed that some tiles don't have a background. This allows us to place tiles on different layers. For example, the house, tree, sign, and rock tiles could be placed on top of the grass, dirt, or puddle tiles.

The magic of tilesets is that they can be used to create many scenes. This means that you can create just one tileset and make a potentially infinite number of scenes from it!

Be Square or Beware

Tilesets can be as simple or as complicated as a game requires, but unlike sprites, it's very important the tiles be perfect squares. Your tiles have to fit together on a grid without any gaps. Most tiles are either 16×16 pixels or 32×32 pixels, but you can make your tiles larger if you need to. You can also split large objects across several tiles within a set.

Getting the right tile size is a balancing act. Smaller tiles give you greater control over edges, so you can make more complex and detailed scenes, but they also mean that making everything match takes a lot more work.

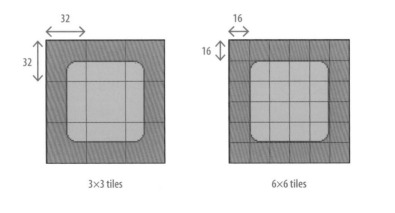

3×3 tiles

6×6 tiles

Cave split across 3×3 tiles

The art may look simple right now, but we can dress it up once it all fits together!

The Plus Sign

When you're making tiles, a good place to start is by creating a plus sign of the set of tiles that need to work together. You can make most of the connections you'll need using this simple pattern. Here, we're using 32×32 pixel tiles, making sure all the connections join at the 16th pixel in any direction. Start by making your tilesets without any complex detail. Save the detail for when you have all the connections you need.

A plus-sign set of tiles

While the plus sign doesn't account for every possible tile you might need, it's a good framework to build on. Even this simple plus sign can create a whole golf course!

Once you have your base tiles set up, you can add more detail and props to create some professional-looking environments and game levels.

Creating an entire golf course

Experiment: Time to Make a Scene

The best way to understand the flexibility of a tileset is to create one. Try creating your own set of tiles for a video game you'd like to design. Draw ground tiles, some buildings, some trees, and other vegetation. Once you have your basic tiles set up, add some props. The setting for your game can be anything you like: a city, a town, a riverside cottage . . . The choice is up to you!

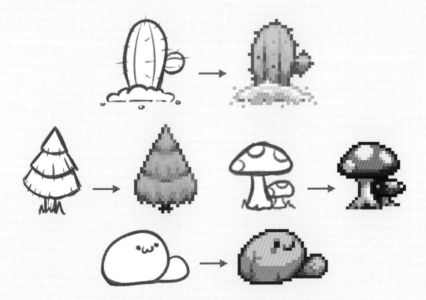

Seamless . . . Unlike Nature

Nature doesn't have tiles, so your tileset might look artificial because of seams. *Seams* are places where it's obvious your tiles have been stitched together. The larger the number of tiles, the worse the seams get.

Here's an example. When you repeat this tile, you'll notice it creates the optical illusion of having a box or circle around each set of dots, making the seams obvious.

To make your tiles as seamless as possible, start by working with just two colors and avoid putting all the detail in the center of the tile. That way, you can avoid circular seams! With this second tile, the detail is spread out, making it much harder for your eyes to draw a mental box around each tile. You can also make the objects in tiles cut off and continue in the next tile over, and then the tiles look seamless when placed together.

Human brains are designed to pick out patterns, so it takes a bit of trickery to get our eyes to take in the whole scene instead of the repetition. Watch out for size differences, too. Anything that is significantly larger or smaller than the rest of the tile will draw your eye. Big differences in contrast, size, and outlines on a tile will trip the mechanism in your brain that detects patterns.

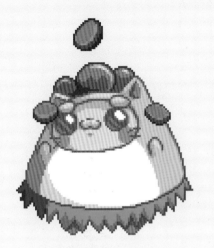

Experiment: Seamless Patterns

Download these objects from *https://nostarch.com/pixelart/* and try making seamless flower, grass, and rock patterns out of them.

Keep in mind that you can make parts of the objects cut off at the edge of a tile and continue on the next tile over. If you're using Aseprite, you can select **View** ▸ **Tiled Mode** ▸ **Both Axes** to easily test how the pixel art you've created looks when tiled.

Creating Game Characters

You've already learned some tips for character design—starting with sketches or silhouettes that block out your character. But you can also think about how your character will move. Does the character fly? Swim? Does it carry weapons?

When you sketch, try to make your character as simple as you can.

If you're stuck for ideas, start with your favorite animal and refine it into a character that will fit into the world you're dreaming of. Let's say you're creating a side-scrolling game and want to make an owl that fires a blaster. You'd start by sketching the side view of the owl, then experiment with adding the blaster to make it look as natural as possible before adding the final detail.

Many character artists design their characters using an *iterative* process. That means they redraw the same character with different details over and over until they get something that feels right. When you're iterating on your own characters, avoid editing the same drawing. Instead, do a fresh drawing for each change. This will help you refine your shapes and get used to drawing your character.

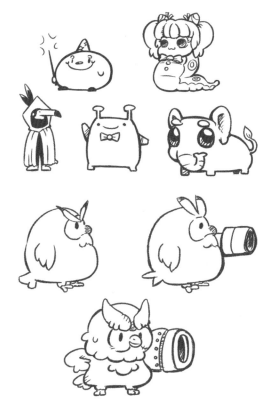

Supersize Your Ideas

When you create characters, make sure you're including elements of varying sizes in your design. You want to lead the viewer's eye to *focal points*, which are parts of the character you want the viewer to pay attention to. Let's look at this little alien character called Verne to see how focal points work.

Our eyes concentrate on small details and relax on large areas. The largest section on Verne is in **blue**. These parts are where your eyes relax. Since there isn't a lot to think about, you can just take in the whole shape. The **green** parts are a bit smaller and act as transitional details that enhance the shape but aren't the focus. Then we have our charming details in **red**. Verne is quite handsome with his little bow tie, and he should be since he's from the planet Handsome!

You may be wondering why I'm referring to this character by name and telling you where he's from. Those details may not matter to the viewer, but giving your characters a backstory and identity can help you develop your character art. Ultimately, those invisible details help form a character with character!

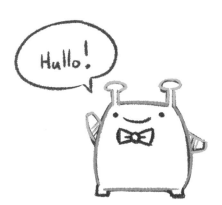

Hullo!

Experiment: Pick 'n' Mix Character Sketching

Practice makes perfect when it comes to character design, but it can be difficult to decide what to draw. An easy way to overcome creative block is to use an *idea matrix*.

Below are three columns containing animals, character types, and weapons. Select one word from each column and combine the three to form a character. Then sketch that character by slowly building up the details. For example, if you chose the first choice in each column, you'd create a knife-wielding samurai dog.

Have fun—and try to sketch at least three characters!

Draw your references in multiple poses so you can solidify your character in your mind. Don't get too attached to one design, as it might not work best for your project. Expect to make changes!

Animal	Character	Weapon
Dog	Samurai	Knife
Cat	Knight	Sword
Rabbit	Rogue	Pistol
Hedgehog	Healer	Rifle
Fox	Tank	Shotgun
Fish	Mage	Wand
Parrot	Assassin	Orb
Badger	Manager	Shield
Sheep	Explorer	Briefcase
Mole	Engineer	Boxing gloves
Snake	Marine	Shuriken

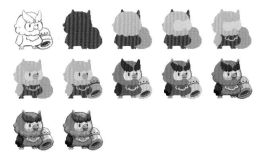

Just Add Pixels

Once you have a character design that you really like, it's time to make it into pixel art. The first drawing of your character as pixel art should be in a resting pose. Remember to start by creating a good silhouette! Once you have a silhouette, you can start adding details one iteration at a time.

If you have trouble going straight from a silhouette to details, block out smaller areas and add details to those, as you see in the example on the left. Think of this as making a silhouette inside a silhouette.

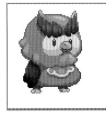

At this point, you might start to see flaws in your original design. For example, the character may be unbalanced, like the eggplant in Chapter 4, or you might spot an area that would prove difficult to animate. To deal with any problems that arise, try breaking your characters into layers so you can swap out parts easily.

Separate all the parts that move independently, as well as any clothing. This process might seem like more work at first, but you'll thank yourself later when you need to make changes. It also makes your characters more customizable. We've made the blaster its own layer, so our blaster owl can upgrade his weapon later!

Charm Points

Since pixel art can be quite simple looking, it's important to use *charm points* to keep your character recognizable while it is moving. Small details catch the eye and allow your character to be recognizable while in motion. Visually, your character can change through upgrades and costume changes, but there always needs to be something to carry the character's identity through, especially if you animate it!

Full-size owl

Let's shrink the blaster owl. The eyebrows and blaster are the charm points, remaining recognizable even when the character is tiny.

Now that we know what this owl's charm points are, we can exaggerate them to drive the point home. Let's make its eyebrows even more noticeable by making them longer and giving them a more saturated color. The blaster is still easy to spot, so we don't need to put extra work into it.

Reduced-size owl

Exaggerated-charm-points owl

Have fun miniaturizing your characters to see whether their features still hold up!

Experiment: Pixel That Pick 'n' Mix

In the previous experiment, I asked you to use the idea matrix to pick some characters to sketch. Now I want you to turn at least one of those sketches into pixel art. Break the character down into layers, think about its charm points, and then shrink your character to see if it remains recognizable.

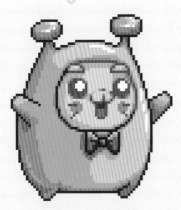

I exist because of an idea matrix!

Making a Character Portrait

Portraits are often useful in games. They can be used during character selection, when viewing stats for each character, or to show which character is talking. They can even be used as part of a damage gauge, changing expression when the character is hit!

Character portraits are usually drawn with the head slightly turned, but many games use front-facing portraits.

Let's draw some portraits! So far, we've drawn a lot of animal characters, but we haven't tried drawing a person yet. For this lesson, we'll go through the steps of drawing a front-facing portrait and learn how to draw a human face. Drawing a human head can be overwhelming at first, but you can break down the head into simpler shapes. Let's start with a circle.

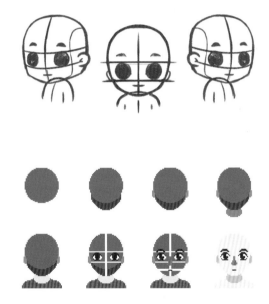

Once you have a circle, you can add more details to the silhouette. Add a chin, a pair of ears, and a neck. If you're having trouble blocking out the shapes, take another look at the elephant example in Chapter 3 and follow the same steps here.

Human faces are *proportional*. That means that parts of the face tend to be in the same places relative to each other. Use guidelines to split up the head into sections. This will help you make the face look more natural and believable. Let's look at how to draw each part of the face and in what proportion.

Eyeing It

Let's start with the eyes. The center of the eye usually lines up with the tip of the ear, so drawing the eyes first will help guide where the ears should be positioned later.

Here's the process I used to draw this character's eyes:

1 Draw the pupils first. Make them as big as you want.

2 Your eyes can have a top lid, a bottom lid, or both. In the example, I drew a top lid complete with eyelashes.

3 The lid is a guide for how thick the white part of the eye should be. Fill the space between the top of the pupil and the lid.

4 Extend the white area down and around the sides of the eyes. You can vary the thickness as it nears the bottom of the eyes to suit the look of your character.

5 Now draw the highlights, which are small white circles on both pupils. This shows light reflecting from the character's eyes and gives them life. Make sure to put a highlight in the same location on both eyes.

6 You can stop at this point, or you can add color around the edge of the pupils and some detail in the center of the pupils. Experiment and see what works.

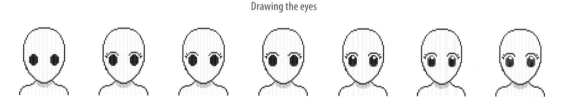

Drawing the eyes

Wiggle Those Brows

Next, let's draw the eyebrows. The key feature of eyebrows is their shape. Once you have that, the rest of the work is simply refining that shape.

Here's the process I used to draw the eyebrows:

1 Draw the base eyebrow shape you want over each eye. You can start with large eyebrows and taper the shape at the edges until you're happy with them.

2 To break up the solid color of the eyebrows, use a slightly darker skin color around the edges, as we've done in the second image here.

When you're making pixel art, keep your earlier lessons in mind. Eyebrows are made up of a lot of little hairs, so you should make sure to keep that texture in your art. You can use a softer eyebrow color to add a few stray hairs or to make the eyebrows look bushier.

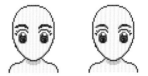

Drawing the eyebrows

Getting an Earful

Next, let's draw the ears. Ears are usually drawn so the tops of the ears line up with the center of the eyes. That's just a general rule of thumb; whether you follow it is completely up to you!

Here's the process I used to draw the ears:

1 Align the top of the ears with the center of the eyes, and draw half-ovals downward. Adjust with the length of the ears and how much they stick out until you're happy with them.

2 Shade the ears slightly darker than the head.

3 You can add additional details, such as earrings.

Remember that if you intend to have both ears look the same, you can simply draw one, then copy and flip it for the other side of the head.

Be a Little Nosy

Next, let's draw the nose. The nose is usually at the center of the face, so if you drew a guideline, make sure your nose lines up with it! Of all the features on a face, the nose has the most shapes to play with. You can give your character a nose that looks natural or something completely ridiculous. The choice is yours!

Here's the process I used to draw the nose below:

1 Using a darker shade of the skin color, draw a shape where the nostrils will be. The lowest point of the nose usually lines up with the bottom of the ears. Just as with all the other features, though, you can adjust the nose up or down.

2 Use two lines that are the same color as the head outline to draw two nostrils at the end of the nose.

3 Shape the top of the nose by erasing or adding to the darker skin color shade you used in the first step. For a smaller nose, erase more. If you want a larger nose, add some more shading!

Adding ears

Drawing the nose

Watch Your Mouth

Finally, let's draw the mouth. Mouth shapes can vary almost as much as noses do, but mouths have the added option of being open or closed. We're going to focus on closed mouths.

Here's the process I used to draw this character's mouth:

1 Draw the lip shape using your preferred lip color. The mouth should be roughly halfway between the nose and the chin.

2 Add a line that is the same color as the head outline across the center of the lip shape you drew. This is where the mouth opens. The shape of this line defines the character's expression. If you make the line go up at both ends, the character could be smiling. If you make the line flat, the character could look indifferent. And if the line is down at both ends, the character is probably sad.

3 Once you've drawn the line, you can extend the lips, depending on the final look you want. As always, experiment!

You now have a basic understanding of how to draw all the main features of a face. The last thing to learn is how to add hair, which we tackle in the next section.

Drawing the mouth

A Hairy Situation

Hair is often layered and has different sections, so you'll usually want to draw hair step by step. Hair comes in different lengths, textures, and styles, so you'll need to decide what the hair should look like before you begin.

Here's how I drew the hairstyle below:

1 Decide what the overall hair shape and length will be. I decided that this character wears her hair pulled back and tied, and I've sectioned the hair accordingly.

2 Draw the sections of the hair. Keep in mind where to make the lines more vertical or more horizontal depending on what part of the head the hair is being pulled around.

3 Add the base colors to the hair. Depending on where the hair is, the base color might be lighter or darker. Hair on top of the head is usually the lightest.

4 Once you have the base color, add shading and then highlights.

For the most part, you can follow these steps to draw hair, but you might need to layer hair differently depending on its texture.

Here, I sectioned the hair into front and back layers to make it easier to apply shading. What type of sectioning you choose to do, if any, is up to you. The sections are visual cues for you to use when you're adding color and shading, so add as many or as few sections as you need.

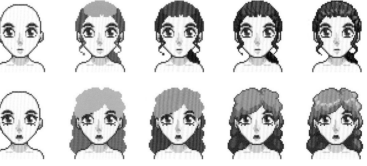

Adding hair

Experiment: Guess Who

Let's finish this chapter by creating faces and hairstyles. Using what you've learned, add facial features and hair to these blank heads. As you're designing these characters, make sure to give them a backstory and identity. That second-to-last head looks a bit alien, doesn't it? Experiment with giving that character (or all of them!) otherworldly features. If you're feeling adventurous, try adding facial hair!

6

Animating Pixels

Animation is a big step for any aspiring artist, and it's also one of the fun things you can do with pixel art! Whether you're making your game characters move, adding an atmosphere to your environments, or experimenting with visual effects, animation is a natural next step once you're confidently creating pixel art.

The best way to learn about animating is to animate, so let's make something move in Aseprite!

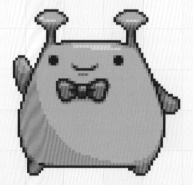

Blobbing Away

We're going to animate a blob character in just a few steps, but before we do, it's important to understand how animation works.

You can see that the blob character has four stages of movement. Each stage is known as a *frame*. To make an animation, you play frames one after another. When frames are played very quickly in this way, the stages of movement blur together so that the viewer sees the animation as one fluid motion. An animation can contain as many frames as you like, but every frame needs to be the same size.

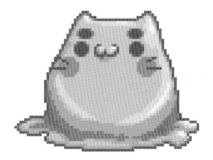

Animations are usually stored in a single file called a *Sprite Sheet*. All the frames are placed next to each other and are treated as separate frames once they are imported into an art program or game engine. For the blob character, each frame is 64×64 pixels, meaning the four frames form a Sprite Sheet that is 256×64 pixels.

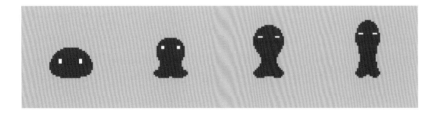

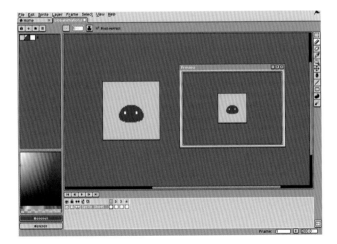

Let's see a Sprite Sheet in action! Download *blobanimation.png* from the book's website and open Aseprite. Just follow these steps to get the blob moving:

1 Select **File ▸ Import Sprite Sheet** from Aseprite's menu.

2 In the dialog that appears, change both the width and height values to **64**.

3 Click **Select File** and open the *blobanimation.png* file you downloaded.

4 Click **Import**.

The four frames of the blob animation are now loaded into Aseprite, but you'll see only the first frame. In the import dialog, we set the width and height of each frame to 64, so now Aseprite automatically splits up the four frames and pops up a preview window. If you can't see the preview window, click the **1:1** button in the lower-right corner of Aseprite to make the pop-up appear.

Below the bottom-left corner of the canvas, you'll notice a set of buttons, which we've reproduced on this page. The buttons include a Play button and the familiar layers interface. Click the **Play** button, and the blob animation you just imported will play in the preview window.

As the animation plays, notice that the focus jumps between the four circles to the right of the layer. Each of those circles represents one of the four frames in the animation. Press the **Stop** button and experiment by clicking the Next Frame and Previous Frame buttons located on either side of the Play button. These allow you to step from frame to frame.

Now, you need to save the animation. You can do that by selecting **File ▶ Save As** and then selecting **aseprite** as the file type. Save the animation file as *blobanimation .aseprite*.

Adding Frames

Now, let's say we want our blob character to also move from side to side. We can make our blob do this by adding some more frames to the animation.

Download *blobsidetoside.png* from the book's website and open Aseprite. Follow these steps to add more frames to your existing animation:

1. Open the *blobanimation.aseprite* file we created earlier, if you don't already have it open.

2. Import the *blobsidetoside.png* Sprite Sheet using the same steps you followed to import the first blob animation.

3. Aseprite will open a second tab containing the eight side-to-side animation frames. Click and drag the mouse over all eight frame circles. You'll know they are selected when the yellow box surrounds the circles.

4. Select **Edit ▸ Copy** from the menu to copy the eight frames you've selected.

5. Switch to the *blobanimation.aseprite* tab in Aseprite and click the fourth frame circle. Add the side-to-side frames after the fourth frame.

6. Select **Frame ▸ New Empty Frame**, which will add an empty fifth frame to the animation without a circle in the box.

7. Click the **fifth frame box** you just added. Then select **Edit ▸ Paste**. This will add all eight frames of the side-to-side movement you just copied to the end of the existing animation.

8. Click **Play** to see the blob character move up and down as well as side to side.

9. Save *blobanimation.aseprite*.

If you're creating an animation from scratch in Aseprite, simply use the **Frame ▸ New Empty Frame** menu option to add a frame to the animation. Once you've added a frame, you can draw within it the same way you'd make any other art in Aseprite. Alternatively, if you select **Frame ▸ New Frame**, Aseprite will create an exact copy of the frame you have selected and add that to the animation. This feature can be very useful, especially if you need to change only a small part of the next frame. For example, you can use this feature when you want to move just the eyes of a character or when you want to make a character wave an arm.

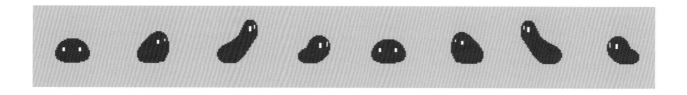

Experiment: Pet Blobs Are All the Rage

Now that you know how to add new animation frames, create some extra frames of movement and add them to the blob character. It's up to you to decide what new movement to add. For example, you could make the blob flatten out like a pancake, or you could form it into a series of different shapes, such as a circle, square, or triangle.

As an added bonus, give the blob a hat. Think about how the blob's movement would affect the position and rotation of the hat in each frame. Remember to use layers to keep the hat separate from the blob character.

Break It Down

If you have an object with lots of moving parts, breaking the object down into shapes can be helpful. Make each shape a different color, and animate each part separately—you'll change the colors later, so choose any color you want for now. Don't worry about adding details quite yet either.

Let's use this blob rabbit as an example. The rabbit's body will change shape as it moves, but its ears will also have their own movement pattern—and so will its little tail. We can split the body, ears, and tail into different shapes and colors to show which parts move independently of each other.

First, we'll animate the body across the frames. Then, we'll go back and add the ear movements. And finally, we'll do the same with the tail.

This method is especially useful for animating more organic objects, but you can use it for anything. By removing the details from your art, you can focus on making sure the animation is smooth.

Experiment: Verne's Family

We met our little alien character Verne in Chapter 5. He's making a comeback in this chapter, but this time, he's bringing along his family. Think about how the different members of Verne's family would move. Break each character down into colored shapes, just as you did with the blob rabbit.

Keyframes and Tweening

Frames that define the start and end points of a smooth transition in an animation are known as *keyframes*. Whenever you are planning out an animation, you should draw the keyframes first. Typically, the first and last frames of an animation are the keyframes, but more complex animations may have several keyframes.

The process of drawing the frames of animation in between keyframes is known as *inbetweening*, which is usually shortened to *tweening*.

First and Last Paths of Motion

When you start a new animation, begin by creating the first and last frame. These will usually act as keyframes. For example, if you're animating a punch, the first frame is the starting idle pose, and the last frame is where the punching arm is fully extended.

Because you now know how the animation starts and ends, planning the motion of the character from one frame to the other is much easier.

The action your character performs during an animation will have a *path of motion* in the form of a shape, such as a wave, line, or arc. By plotting the path of motion, you can create a guide for the tweening frames. Let's use an animation of a character kicking as an example of how to use the path of motion.

First Last

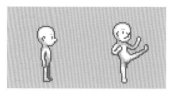

First, we create the keyframes. The first frame will be the character standing, and the last frame will be the character with one leg fully extended in a kicking stance.

We can then add the path of motion the leg takes to get from one keyframe to the next.

In this case, the path of motion is an arc. Using this as a guide, we can add several tweening frames showing the leg kicking. Remember to look at real-life examples of movement when you're animating. In some cases, the movement will be a little different from the path of motion. For example, when you kick your leg, you might notice that you need to shift your balance first. In this animation, the character's weight shifts backward so the kicker doesn't fall over before unleashing the kick.

Animations often have more than one path of motion, some subtler than others. When you identify and draw the main path of motion, it becomes clearer what else needs to move during tweening.

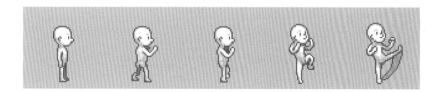

Multiple Motions

Some actions require motion in more than one direction. A good example is when a character swings an object around. For example, here are keyframes of a character swinging a sword. The first keyframe shows the character holding the sword ready to swing it, whereas the end keyframe shows the completion of the sword's downward swipe.

The path of motion could just arc down from where the sword starts in the first keyframe to where it ends in the second keyframe, but think about how someone usually swings a sword. The first thing they do is pull their arm back so they can hit their opponent harder, and then they'll swing down. That means the path of motion extends behind the sword's start position, too.

Not only does the path of motion act as a guide for tweening, but it also forces you to think about the

movement before spending any time drawing frames. This can save you time. In this case, we could have gone straight into animating the sword, but we might not have realized the sword needs to go up before swinging down. The final set of frames ends up looking like this.

If you're stuck as to how a character or object should move, then look for real-world examples. I watched a few sword-fighting videos on YouTube before creating the sword swing animation for this example.

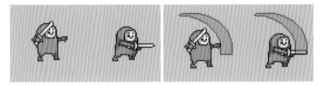

Keyframes Path of motion

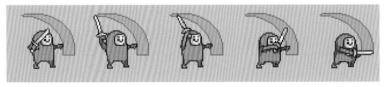

Final set of animation frames

Experiment: During the Fall

Now that you know how a path of motion can help you plan an animation, draw a path for this character who is tripping and falling to the ground. What path would the body follow to reach the second keyframe? As an added bonus, try drawing the tweening frames. Think about what the character's arms, legs, and head would do during the fall.

Frames for Movement

Different projects will need different numbers of frames per animation. Two-frame animations are rarely advised because your animation would be jerky. For example, in this walking animation, you have to choose between both feet hitting the ground or both feet recoiling. On the other hand, this frame count works well with games that are low detail with very small sprites. Avoid using more frames than necessary, but make sure you have enough for the motion to be believable.

With four frames, you can have a full walk cycle with each foot clearly hitting the ground and recoiling before the next foot takes a step. Again, you want to keep the sprite size relatively small for this number of frames.

With six frames, or even eight frames, you can show the full motion of the leg swinging forward, hitting the ground, and moving back relative to the body as the frame moves to the next leg.

Two frames

Four frames

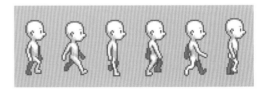

Six frames

Walk Cycling

The *walk cycles* we just saw are a vital part of most animation projects that involve legged creatures (like us!). When creating a walk (or run) cycle, you'll often use four keyframes, like these.

If the characters are small, you might be able to get away with fewer frames or with reusing frames that are very similar to each other.

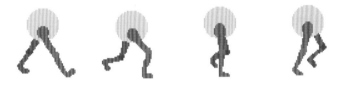

From left to right: foot forward, down and pull, push up, launch

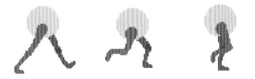

From left to right: foot forward, down and pull, push up

Experiment: Quadruped

When making a four-legged animal, you can break the animation down into two parts. You could animate the back and front legs together, or you could make the opposing legs move at the same time. Try to imagine how this animal would walk by watching how a similar real-life animal would move!

Focus only on two legs to start. You can try adding more after.

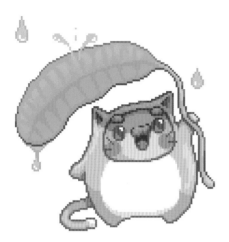

Life Has Pointless Movements

Living objects breathe. Even if an object doesn't breathe, the environment is still pushing it around. Most objects have *idle movements*, which means the objects move naturally even when nothing is happening. For example, people and animals (and sometimes other weird substances) are fidgety, and their bodies constantly move in very small ways. Your chest rises and falls slightly with each breath, and after standing for long periods of time, you might shift your weight from one leg to another. Things such as wind, rain, cold, and heat can also cause subtle movements in inanimate objects. For example, imagine a rocking chair on a breezy day.

You might get away without idle movements when animating small characters and objects, but the more detailed your pixel art is, the more awkward it becomes for it to move only when it is doing something meaningful. Download *vegetation.png* from this book's web page, import it into Aseprite, and play the frames to see this vegetation's subtle motion.

Color Changes Are Motion

In some cases, you could have size restrictions on your projects, so you might not be able to move or change the shape of an object. In those situations, you can still make an animation by changing the color or shading of your pixel art.

By extending the traveler's mouth and making their blushing cheeks move up and down, you make it look like they might be chewing. The movements are so subtle you'll have to look really hard at the paper to notice. That's how small the changes will be. Try adding little changes such as chewing, blinking, or squinting to characters and objects you've made from previous chapters and see what you come up with.

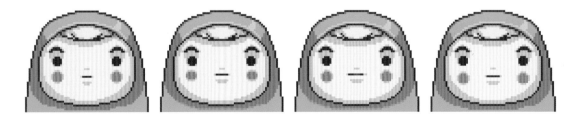

Experiment: Pointless Exercise

Can you give this traveler's face an idle movement? What would happen to their hair and clothing if a slight breeze were to come by?

Download *travelershead.png* from this book's web page and load it into Aseprite. You'll notice the file already includes the chewing frames mentioned in the previous section. Add movements one at a time. Start with getting one movement right, such as the hair blowing in the wind, and then focus on the others. You will need to make sure you have enough frames to return the animation from the peak of action to its resting state. Be aware of frame limitations in your projects.

7

Special Effects for Animation

In Chapter 6, you focused on making your pixel art look like it was moving using animation. But animation isn't just about movement—it's also about creating *visual effects* or *special effects*. Whenever you see an explosion in a game, that's an animation. If a flame flickers or an object shows increasing amounts of damage, that effect is also created by frames of an animation. There are so many special effects that we could write an entire book just about them! Since we have only one chapter, we'll focus on some of the most common and useful effects you can create using pixel art. Let's dive right in!

Flame Effects

Let's start with a simple effect: flames. You can break fire down into colors and shapes. The simplest of flames are made up of just two colors, like the yellow-and-orange candle flame here. Without any flickering, the flame's outer orange shape is a teardrop shape, and the inner yellow flame is a smaller teardrop.

Making the Flame Flicker

Realistic motion is achieved by making the inner yellow flame move around inside the confines of the orange flame. The yellow flame never breaks through the orange that surrounds it but is always trying to escape and never stops moving.

A good way to think about the candle flame animation is as a fight between the colors. The yellow part of the flame pushes against the orange flame. Each push moves the orange ever so slightly in the same direction. Sometimes the yellow part will pull back for a frame or two, then thrust itself against the orange part with more force, triggering an even bigger reaction from the orange part.

The flame's shape can also be affected by wind or other forces. You can use this effect if a character runs past a candle in a game or a door opens, letting in a breeze. Also, when the flame is very active, pieces of it escape into the air.

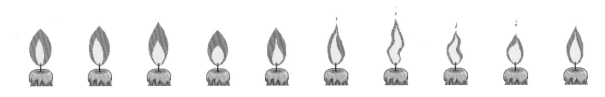

Experiment: Flickering Flame

Try re-creating the frames of the candle flame and watch the animation to see how it moves. Now, create your own two-color flame with a different movement pattern. You can also experiment with different color combinations!

Lasers for Blasters, Trip Wires, and More

Lasers are one of the most versatile effects you can use and are well worth mastering. They're useful for depicting laser blasts, trip wires, lightning bolts, and that *Star Wars* classic, the lightsaber.

Let's create a simple laser beam and see how it can be used in different ways!

1 Load up Aseprite and draw a white line of any length.

2 Give the laser an outline color by adding a thinner line to the top and bottom of the white line. Here, we used a light green.

And that's it! You can vary the outline color however you like, and you can also reuse the laser effect for different pixel art pieces. For example, here's the same laser used in a lightsaber and a firing blaster. Keep in mind that you can always tweak your lasers when you reuse them. For example, to use my laser in a lightsaber, I made the outline color darker on one side of the laser to make it stand out.

Layering Effects

We can tweak the laser to make it look even better when fired out of the blaster. To do this, just add a few more special effects. First, we can add a few frames of the laser blast building up at the tip of the blaster. The ball of circular energy will turn into the laser beam once it reaches full intensity.

In these five frames, the thin laser beam gets thicker before thinning out and disappearing. When you play all of these frames together as an animation, it will look as though a pulse of energy becomes a laser blast and then subsides.

You could create a similar effect when turning on the lightsaber, only the beam would extend and thicken more slowly and remain a set thickness and length until turned off.

Experiment: Pulsing Trip Wire

Another common laser effect is the trip wire, which is typically placed near the floor, across a potential intruder's path. When someone walks through it, they break the beam of light and set off an alarm.

A trip wire consists of a one-color, semitransparent (50 percent opacity) line that is slightly darker at either end. Varying the opacity over multiple frames creates a pulsing effect.

Try creating a trip wire laser and making it pulse across multiple frames. As an extra challenge, make a pulsing grid of trip wires using different colors.

Making It Glow

Being able to make something glow comes in handy when you're creating a light source or trying to draw the viewer's attention to a specific area of the screen. To create a glow effect, you'll need a mix of high-contrast colors around a central glowing point. With very little work, you can create an object that looks as though it's emitting a bright light, like a lantern.

Creating a glow is all about creating rings of color. The center is the brightest part of the light source and should be surrounded by rings that become darker and larger. The easiest way to create this effect is by drawing four circles, each larger than the last, and overlaying them. Make the smallest circle white. Then pick a color to use on the outer rings. I used blue for the lantern, but you can use any color to make a glow. Here's the process I used to create a green glow.

A nice additional step is to add dithering to the edge of the largest ring.

A glow doesn't have to be static. For example, say you are making a bright comet traveling through the sky. The comet's body will be a bright white circle, just as in the lantern. The rings of color will become a trail behind the comet, suggesting movement, and you could also animate this movement.

Blowing It Up

Explosions are a must-have for any action game! When making an explosive animation, you should focus on four things: flash, force, fire, and residue. Let's break the animation down from beginning to end.

Flash

Big booms often overwhelm your vision for a split second, so you just see a flash and a blackout when it starts. Though a flash isn't necessary for all explosions, it helps your animation look realistic. Some games even black out your entire screen and add flickering effects!

Force

Decide where you want the force of the explosion to go, keeping in mind the shape of the object where the force started. Was it spherical? Bullet shaped? Is it a water balloon bursting or a missile hitting its target?

An explosion in open space will expand uniformly in all directions. Draw an outline of where all your explosion's force will go.

Also consider how explosions interact with solid objects, such as a wall. The shape of the blast changes, as you can see when the explosion happens against a flat wall or a corner.

Engineered explosions may create nearly perfect spheres, while natural explosions (such as avalanches or volcanoes) are often more chaotic.

No matter what kind of explosion you are making, start with the outline and make sure you're happy with the way the force looks before moving on. In the next phase, you'll need to use the shapes you created to add fire effects. As ever, experiment!

Fire

Let's take a close look at an explosion animation I made. In the first few frames, the fuel of the explosion is burning. In the final stages, you can see smoke and residue, as well as the arc of movement from the force of the explosion.

Where there's smoke, there's fire. You'll need to add columns of smoke that become wider as they disperse upward. If your scene is windy, make sure the smoke trails off as it blows away, too.

All Together Now

Now that we have all the parts of an explosion, let's put everything together:

The last frame shows the explosion's aftereffects. For this bomb, small fragments hit the ground all around the initial explosion; this effect is called a *secondary impact*. Keep in mind where the explosion is happening. If the explosion went off in midair, there probably won't be a secondary impact, and there definitely wouldn't be one in outer space where there isn't gravity!

Experiment: Wall Explosion

Practice your skills by creating the full sequences for the explosions against the solid, flat wall and the corner of the wall.

Damaged Goods

Things rarely stay in mint condition for long, especially when exposed to the elements—painted surfaces chip, bicycles rust, and street lines fade. Wear and tear can imply neglect and decay, setting the scene for a poor section of town or a dystopian future. Things that are too perfect can end up looking wrong or out of place, so a little damage adds realism. Different materials behave in different ways, so let's go over a few examples and break down the basics of breaking stuff.

Damage Over Time

Animation doesn't need to happen in one fell swoop. It can happen slowly over time. For example, you could make both undamaged and damaged versions of an object that you change out as the story changes or to show the passage of time. Plan ahead and think about what you will need for your animation or game.

Try to think of other ways you could destroy this box. What if it fell out of a window or had a toxic chemical spilled on it?

Undamaged

Struck

Burned

Crushed

It's All in the Materials

The material an object is made from determines how much damage can be done in different ways. Metals get scratched and bent but are much harder to break or crush. Cloth tears, jelly gets smooshed, and wood splinters and fractures.

Keep in mind that the characteristics of the material also matter. For example, damage from perforation would only happen with thin metal, not a solid steel block. In cartoons, animators sometimes make a strong object behave like a fragile one to emphasize its destruction (for example, steel could turn into powder or even shatter).

Think of how objects interact, too. When you hit a solid metal robot with your fist, you're more likely to damage your hand than the metal. On the other hand, having a character damage metal with their bare hands is a good way to show how powerful they are. You can't punch through steel, but maybe your video game alter ego can!

Undamaged

Scratched

Dented

Perforated

Damaging Soft Objects

Some materials are less structurally sound, and you might struggle with figuring out how they'd look when damaged. For example, jelly doesn't have much integrity. It just takes the shape it was molded into and only retains that shape if handled delicately. It doesn't take much time for it to fall apart, and it's very obvious if someone takes a bite out of it!

The less structural integrity an object has to begin with, the more liberties you can take with how it falls apart. Keep the initial volume of the object in mind when drawing a damaged version so it looks realistic.

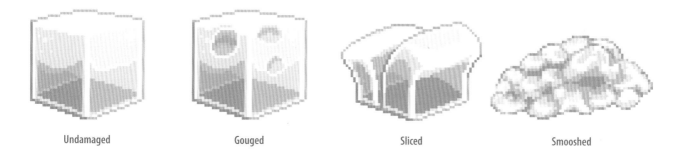

Undamaged Gouged Sliced Smooshed

Experiment: Beat 'Em Up!

Download the image files of the wooden, brick, and metal buildings from the book's website and set about damaging each of them. How would these buildings look after being battered by a hurricane or if a vehicle drove into them? What about damage caused from general wear and tear after years of being exposed to the elements? Have fun experimenting with other types of damage, too!

Layering the Damage

We've already covered how useful layers can be when creating a character. The same is true when depicting damage to characters.

Imagine you're creating a game and need to show the player how much damage they've dealt to an enemy. A great way to do this is by switching out different parts of the enemy for damaged alternatives using layers. For example, you could create four layers for the enemy's arm in different damaged states such as undamaged, slightly damaged, badly damaged, and destroyed. As long as the layers are independent of any animation, they can be switched without breaking the movement patterns.

This method requires you to take a more modular approach to your character designs, which isn't a bad thing. Planning out your characters in advance and splitting their parts across multiple layers gives you more flexibility and is well worth doing. If you want to add more damaged states to your character later, all you'll need to do is draw some more layers!

Experiment: Damaged Character

Sketch a character design on paper and then split it into parts. For example, split up the character's arms, legs, torso, and head. If your character isn't humanoid, it may instead have wheels, a lower body, an upper body, wings, and so on. Using layers, draw the undamaged versions of the character parts. Now, focus on each part and create slightly damaged and badly damaged versions on separate layers. Once you're done, you'll have a character that can be put into lots of different states of damage simply by switching out layers.

A Little Science Before the Fall

While you don't have to be a physics major to create animations, you need to know a little bit about how things fall. Objects fall in different ways. You've probably chalked this up to gravity, but what really affects how an object falls to the ground is *air resistance*. As an object falls, it must push the air around it out of the way, but the air pushes back. A parachute will fall slowly because it drags through the air, whereas a round, highly aerodynamic scoop of ice cream falling from a cone will splatter on the ground before you know it!

Therefore, when an object falls, you need to consider its weight and shape. A heavier object with a small surface area to press against the air falls faster. Bullet-shaped objects tend to point nose downward as they fall because that's where they have less surface area and where air pushes against them the least. They're shaped to cut through the air. Feathers, on the other hand, are designed to help birds stay aloft, and they tend to drift around.

When the Can Drops

At the end of every fall is an impact that needs animating!

Depending on the object you've dropped, the impact can vary greatly. Imagine you've dropped a glass bottle, a water balloon, and a soda can onto a hard surface. They all contain liquid, but their impacts are all quite different. The glass bottle will smash, and the liquid will splash out. The water balloon may bounce and deform,

keeping the liquid inside. The soda can is full of fizzy liquid, so the contents will burst out as though you've shaken the can.

When you're not sure how an object will behave, look for real-life counterparts you can observe and mimic in your art. You could also carry out the experiment yourself and record the result. Just keep safety in mind when you do so.

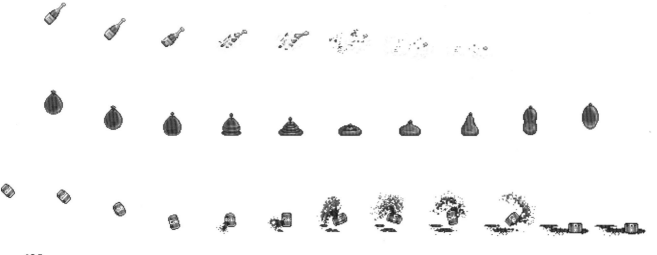

Experiment: Fallen Objects

Try to imagine how this bag of groceries, jar of pickles, and pudding cup would fall. Then animate them accordingly. What will happen when these objects hit the ground? You can download the files from *https://nostarch.com/pixelart/*.

Revise, Revisit, Reuse

After making so many animations and special effects, you've probably realized that it takes time to go back and revise your creations. You might need to take a few tries to get a movement looking just right. Don't worry—this is part of the process!

If an animation is proving difficult to perfect, step back, take a break, and revisit it later. You can rethink the animation and try a new approach, or you might try animating something else so you get a fresh perspective. It's okay to start over, too!

Another thing to keep in mind is that the more animations you make, the more material you have for reuse. You'll notice that some of your animations will have similar movements. For example, explosions come in many forms, but the basic motion stays the same. When creating a new animation, ask yourself what animations you already have created and whether you can recycle any of the material.

Research!

When creating an animation of an object you've never dealt with before, it can be helpful to do research. Even if the object is made up, you can probably find something similar in real life to use as a reference point. Here are a few things that will help you figure out how objects move and react in different situations:

- Videos on the internet: slow-motion, high-FPS (frames per second), and time-lapse videos are great
- Action analysis and animation workbooks
- Pencil tests from other animators
- Online animation archives
- Yourself! Take pictures or record video of you and your friends performing the actions you want to animate.

Even professional animators do studies and research before embarking on a new animation. In fact, this careful study is part of what makes them professionals. Don't feel embarrassed that you can't animate from scratch when starting out. Research is part of the job!

8

Where to Go from Here

Throughout this book, you've learned how to create pixel art, but that's just the first step in what could turn into a fun hobby—or even a career! To keep having even more fun, master your craft, and hone your skills, you'll need to make sure you're always improving, staying motivated, and getting noticed. In this chapter, we'll show you the best ways to keep cultivating your newly learned skills and how to share your creations with the world.

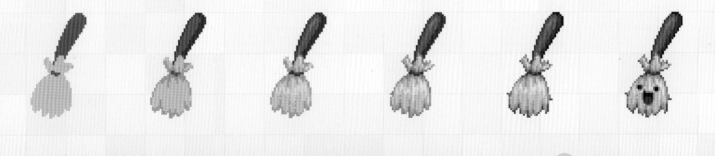

Review Your Work Once a Year

Motivation is important. If you don't keep your passion alive, it will be hard to sit down each day to make sketches and pixel art. The quality of your art will also suffer, and that will lead to feeling even less motivation!

One of the best ways to combat demotivation is to redo an old piece of pixel art so you can see where you've improved. You'll be surprised by how much even a month of practice can improve your skill.

Don't believe me? Here are some works I made in the late 1990s compared to new versions I created while writing this book. As you can see, I've improved a lot!

No one starts out drawing masterpieces. Sometimes it seems that way because we don't see the hard work behind a professional's talent, but everyone starts off as a beginner.

Make a Plan

A skill is like a muscle: you need to work it out regularly to strengthen it. If you have a goal and a plan to achieve it, regular workouts become much easier. You don't have to figure out what to do each day—you just follow your plan! Whether you're planning a large piece or how to improve over the long term, write down what you want to accomplish and the steps you'll take to work toward it, taking it a week at a time so it's not overwhelming.

You can do this right now! Grab a piece of paper and write down the first letter of each day of the week from Monday to Sunday. Starting with Monday, write down one art task you'll do each day. You could sketch every day or break down a single pixel art piece over several days. For example, one day could be research, and you could use the other days of the week to do tasks to finish the piece.

Planning out your week will motivate you to do something art focused every day. You can reinforce your feelings of accomplishment by ticking off each day as you complete the task you set. At the end of the week, you'll have a nice reminder of the work you did—and the motivation to do it again the next week.

If you miss a day, don't worry! You don't have to follow the plan perfectly—just keep making plans and keep ticking off daily tasks. You'll see improvement before you know it!

Plan for the Week

M	Research Monster Designs
T	Sketch a Monster
W	Sketch Scared Human Faces
T	Experiment with Monster vs. Human Size
F	Sketch a "Humans Attacking Monster" Scene
S	Draw Monster Scene in Aseprite
S	Color Monster Scene and Post on Facebook

Use the Tools You Have

You won't always be near a computer to draw pixel art, but you'll always have other tools you can use to work on your skills. Therefore, it's important to learn how to draw with whatever tools you have.

There is no perfect tool, paper, or technique that is going to make you a good artist. The key to improving is practice. If you have access to a computer and pixel art software, use it, but keep in mind that a pencil or pen and paper work just as well for sketching out your ideas. Sometimes I even draw on the skin of my oranges with a marker at breakfast.

Any pencil is a door to new ideas!

Sharing Your Work

You've made your weekly plans, your motivation is high, and you're creating new pieces of art regularly. Next, you'll want to share them with the world. It can be scary to ask others for feedback, but whether good or bad, you need criticism to help you grow as an artist. Your friends and family might respond positively no matter what work you show them, but both positive and negative feedback will highlight where you need to focus and improve. This is why sharing your work online can be useful.

You can share online in many ways using popular social networks and art-focused websites. We'll cover some of the best sites to use.

Keep in mind that you don't have to use all these services to share your art, but you should pick at least a couple. When you do go online, don't be put off if you receive some particularly nasty feedback. Not everyone on the internet is a nice person, and we all end up ignoring and blocking a few people. You'll learn to distinguish between valid constructive criticism that you should take to heart and mean comments written by mean people, which say far more about those people than about your art.

Preparing to Share Your Work

You have a choice of many popular social networks and websites for sharing your work, but the file formats and automatic art scaling that websites use can test your patience. The good news is that you can take steps to ensure your art looks good regardless of what format or size a website wants!

When you upload images, websites sometimes automatically convert them into the size or file type the website uses. Unfortunately, this can make your pixel art look different than you intended. Whatever your pixel art is, scale it up to at least 512×512 pixels using nearest neighbor resizing. This will add identical pixels next to each pixel in your art and keep the final image from looking blurry. If a platform insists on using a specific file type, convert your art to that file type yourself rather than relying on the website's converter.

A lot of social networks won't let you upload an image with a transparent background, so use a background color that makes the image pop. Remember to use neutral background colors like we talked about in Chapter 3. Finally, if your uploaded art still doesn't look good, try first adding it to an image-sharing service, such as Imgur (*https://imgur.com/*), and then sharing a link to your art.

Now that you have some tips on how to share your art, let's look at the platforms you can use for sharing!

Facebook

Facebook (*https://www.facebook.com/*) is by far the largest social network in the world, with well over 2 billion users. Signing up for an account is free and easy, and you can instantly start posting images of your sketches and artwork on your timeline or in pixel art groups. It's a great place to get feedback since other Facebook users will see your work and might click the Like button or leave a comment for you to read.

Twitter

Twitter (*https://www.twitter.com/*) allows you to attach an image to each tweet (message) you post. You can also use a Twitter hashtag on your tweets so that other people can search for and find them. A hashtag is simply a hash mark (#) followed by a phrase spelled out without spaces. A good keyword to use when you're tweeting about your art is #pixelart. In addition to sharing art with others, you can follow other artists on Twitter to get new ideas and stay motivated.

Pinterest

Many artists use Pinterest (*https://www.pinterest.com/*) to upload and share their creations. It's a great way to keep a growing archive of your work, since you can upload your art or even "pin" your art to Pinterest from other sites you've posted to. Sign up, and every time you create a sketch or pixel artwork, upload it. Over time, you'll have a record of your work that shows how your skills have improved.

DeviantArt

DeviantArt (*https://www.deviantart.com/*), a website dedicated to sharing artwork, has a passionate community of over 45 million members. Signing up is free, and you can not only upload and exhibit your artwork for feedback but also sell prints and digital downloads of your work.

Pixel Joint

Pixel Joint (*http://www.pixeljoint.com/*) is a website dedicated to the pixel art community. On top of being a place where you can upload artwork, Pixel Joint actively encourages creation with weekly challenges and regular artist showcases. You can also discuss pixel art in the very active forum, as well as collaborate and chat about challenges.

Recommended Reading

Artists should never stop learning, and that means reading as well as drawing! In addition to reading this book (thanks, by the way!), here are some other excellent resources you can check out:

- *Fun with a Pencil* by Andrew Loomis
- *Successful Drawing* by Andrew Loomis
- *Drawing on the Right Side of the Brain* by Betty Edwards
- *Color* by Betty Edwards
- *The Artist's Guide to Human Anatomy* by Gottfried Bammes
- *The Animator's Survival Kit* by Richard Williams
- *Cartoon Animation* by Preston Blair
- *Advanced Animation* by Preston Blair
- *Action Analysis for Animators* by Chris Webster
- *The Illusion of Life: Disney Animation* by Ollie Johnston and Frank Thomas

Experiment: All Done?

Not so fast! Now that you've started your pixel art journey, let's do one more experiment to see how much you've improved!

Think of a pixel art scene you'd like to create and make a plan to break the work down over seven days. Every time you produce a sketch or reach an interesting point, share your progress on your favorite social networks and image-sharing sites. You can use the hashtag #MakeYourOwnPixelArt to find and share your pixel art with other artists who have used this book!

As a bonus, draw your own pixel artist badge and share it along with the hashtag to show you've finished the book. You're officially a pixel artist now, so wear that badge with pride!

Thank You!

Readers are what make a book like this possible. The more support we have from readers like you, the more books we'll be able to create for other budding artists. We'd like to thank you for reading this book, and we hope that following these exercises has helped you along your way to becoming a pixel artist.

All that we ask of you now, dear reader, is to continue improving your skill. We hope that you keep working on your pixel art skills, stay motivated, and keep sharing your work. But most of all . . . have fun doing it!

appendix
Aseprite Shortcut Cheat Sheet

If you are working on a Mac, use the Command key in place of the CTRL key. Keyboard shortcuts can be edited under **Edit ▶ Keyboard Shortcuts**.

Aseprite is in active development and new features get added regularly. This can mean shortcuts change or new ones get added. Visit the Aseprite website regularly to find out what's new or different!

File

Command	Shortcut
New File	CTRL-N
Open File	CTRL-O
Save	CTRL-S
Save As	CTRL-SHIFT-S
Close File	CTRL-W
Close All Files	CTRL-SHIFT-W
Export Sprite Sheet	CTRL-E

Drawing

Command	Shortcut
Brush Size	+/-
Eraser	E
Eyedropper	I / ALT-right click / ALT-left click
Line/Curve	L/SHIFT-L
Paint Bucket	G
Pan	Hold the middle mouse button and move the mouse
	Hold the spacebar and then right-click or left-click
	Hold the spacebar and then press the arrow keys
Pencil	B
Rectangle/Ellipse	U/SHIFT-U
Replace Color	SHIFT-R
Undo/Redo	CTRL-Z/Y
Zoom	Z
	Scroll wheel
	1–6 keys

Selecting

Command	Shortcut
Cut/Copy/Paste	CTRL-X/C/V
Select All	CTRL-A
Deselect	CTRL-D
Invert Selection	SHIFT-CTRL-I
Rectangular Select	M
Magic Wand	W
Export Sprite Sheet	CTRL-E

Transforming

Command	Shortcut
Flip Horizontal	SHIFT-H
Flip Vertical	SHIFT-V
Angle Snap	Hold SHIFT (while rotating)
Keep Proportions	Hold SHIFT (while scaling)
Move Layer	V
Move Active Selection	Arrow keys
Export Sprite Sheet	CTRL-E

Timeline/Animation

Command	Shortcut
New Layer	SHIFT-N
Frame Properties	P
New Frame	ALT-N
New Empty Frame	ALT-B
Delete Frame	ALT-C
Next/Previous Frame (when timeline is active)	Left/right arrow keys
Play/Stop Animation	ENTER
Preview	F7
Clear Frame	DEL/BACKSPACE with active cel selected
Select Cel Content	CTRL-T
Timeline On/Off	TAB

Extras

Command	Shortcut
Snap to Grid	SHIFT-S
Grid Toggle	CTRL-'
Pixel Grid Toggle	CTRL-SHIFT-'